The Photoshop CS4 Companion

for Photographers

The Photoshop CS4 Companion

for Photographers

DERRICK STORY

O'REILLY®

Beijing · Cambridge · Farnham · Köln · Paris · Sebastopol · Taipei · Tokyo

The Photoshop CS4 Companion for Photographers
by Derrick Story

Published by O'Reilly Media, Inc. 1005 Gravenstein Highway North, Sebastopol CA 95472

O'Reilly books may be purchased for educational, business, or sales promotional use. Online editions are also available for most titles (safari.oreilly.com). For more information, contact our corporate/institutional sales department: (800) 998-9938 or corporate@oreilly.com.

Editor: Colleen Wheeler
Copyeditor: Audrey Doyle
Production Editor: Michele Filshie
Proofreader: Nancy Reinhardt
Technical Editor: Tim Grey
Indexer: Ted Laux
Interior Design: David Futato, Ron Bilodeau, David Van Ness
Cover Designer: Steve Fehler
Cover Photographer: Derrick Story

Print History: October 2008, First Edition

ISBN: 978-0-596-52193-6
[F]
Printed in Canada

The Photographer's Five Steps to Photoshop Fulfillment

1 *Move your images to your computer with Photo Downloader*

2 *Choose your best shots in Bridge*

3 *Make your best shots look better in Adobe Camera Raw*

4 *Fine tune the chosen few in Photoshop*

5 *Share them with the world*

Contents

Introduction
Just What Photographers Need (and Nothing They Don't) xi

CHAPTER 1 **The Quick-Start Road Map**
An Overview of the Photoshop CS4 Workflow 1

Your Digital Darkroom . 2
The Basic Steps . 3
Let's Get to It! . 4

CHAPTER 2 **Importing Your Images**
The Power of Photo Downloader . 5

Before You Start Downloading . 6
Creating Your Personalized Metadata Template 6
Launching Photo Downloader 8
Time to Choose Your Backup Strategy 9
Importing Photos from Your Camera . 12
Basic Options in Photo Downloader 12
Advanced Photo Downloader Options 16
Applying Metadata During Download 20
Where to Go from Here . 22

CHAPTER 3 **Rating and Keywording Images**

Photo Editing in Bridge . **23**

 Setting Up Your Workspaces . **24**
 Creating the Overview Workspace 26
 Creating the Photo Edit Workspace 30
 Setting Up the Keywording Workspace 31
 Organizing Your First Batch of Images **33**
 Step 1: Reviewing Your Shots in the Overview Workspace 33
 Step 2: Photo Editing: Sorting Your Pictures 35
 Rating and Sorting Tips . **38**
 Tricks for Comparing Two Photos 38
 Using Smart Collections 41
 RAW+JPEG 42
 Introduction to Keywording . **43**
 Tools for Searching by Keywords 43
 Adding Keywords to Your Images 44
 Where to Go from Here . **46**

CHAPTER 4 **Basic Image Editing in Camera Raw**

Initial Color and Tone Adjustments . **47**

 The Benefits of ACR . **50**
 Working on Images in ACR from Bridge **50**
 Setting Your Workflow Options 51
 A Quick Tour of the Bottom Buttons 53
 Your First Image Edit . **54**
 Start by Cropping 54
 First Edits in the Basic Tab 55
 Fine-Tuning Your Image . **59**
 Fine-Tuning in the Basic Tab 59
 Fine-Tuning Tonal Adjustments in the Tone Curve Tab 59
 Fine-Tuning Color in the HSL/Grayscale Tab 64
 Finishing Touches in the Detail Tab . **66**
 Input Sharpening 66
 Noise Reduction 68
 And These Were Just the Basic Tools **68**

CHAPTER 5 **Advanced Camera Raw Techniques**
Great Tools for Your Best Shots 69

 Batch Processing in ACR 70
 Black-and-White Conversion in ACR 72
 The Convert to Grayscale Approach in the HSL Tab 73
 The Desaturate Approach in the HSL Tab 74
 Spot Removal in Adobe Camera Raw 75
 Cloning with the Spot Removal Brush 77
 Localized Corrections with the Adjustment Brush 78
 Tonal and Color Adjustments with the Graduated
 Filter Tool ... 81
 Types of Graduated Corrections Available 83
 Adjusting a Sample Image with the Graduated Filter Tool 83
 Where to Go from Here 86

CHAPTER 6 **Refining Your Image in Photoshop**
Powerful Tools When You Really Need them................. 87

 Touching Up Imperfections with the Clone Stamp Tool 91
 How to Save Photoshop Files 94
 Adjusting Tone with a Levels Adjustment Layer 96
 Creating the Levels Adjustment Layer 96
 Adding a Mask to the Adjustment Layer 101
 Nondestructive Sharpening with Smart Objects 106
 Back to Nondestructive Sharpening 109
 Where to Go from Here 112

CHAPTER 7 **Photoshop Recipes for Photographers**
A Collection of Useful Techniques for Specific Situations 113

 Portrait Retouching Techniques 114
 Recipe 1: Brightening Teeth 115
 Recipe 2: Touching Up Blemishes 117
 Recipe 3: Darkening or Lightening Facial Features 118
 Recipe 4: Softening Skin 120
 Recipe 5: Brightening Eyes 121
 Recipe 6: Sharpening Eyes and Eyebrows 122
 Recipe 7: Softening Dark Circles Under the Eyes 123
 Recipe 8: Bumping Up Contrast with Unsharp Mask 125
 Recipe 9: Stamping Layers to Pull Your Adjustments Together 126

Adjustments in the World Around Us 128

 Recipe 10: Correct Architectural Distortion 128

 Recipe 11: Retrieving a Blown-Out Sky 131

 Recipe 12: Applying a Color Wash to an Object 134

 Recipe 13: Changing the Color of an Object
 (More Flexible, but More Elaborate) 137

 Recipe 14: Changing the Hue and Saturation of an Object
 (The Easy Method) 142

Finishing Touches . 144

 Recipe 15: Creating a Virtual Custom Matte 144

 Recipe 16: Automating Panorama Merging 145

 Recipe 17: Extending Depth of Field by Stacking Images 149

 Recipe 18: Optimize Images for the Web Without Losing
 Copyright Information 153

You're a Photoshop Artist; Now What? 154

CHAPTER 8 **Printing**

Using Photoshop to Control Your Printmaking 155

 Calibrating Your Monitor . 156

 Calibrating on Mac OS X 157

 Calibrating on Windows 158

 Calibrating in General 159

 Dedicated Photo Printers . 160

 Ten Steps to Making a Beautiful Print 161

 A Word About Printer Profiles . 164

 Success! A Beautiful Print . 165

 Improving Your Photography Through Printing 166

 Final Thoughts . 168

APPENDIX **About the Photos in this Book**

 Cover Images . 170

 Frontmatter Images . 173

 Chapter Openers . 174

 **Special Thanks to Those Who Helped Me
 Make These Images** . 179

Index 181

Introduction

As you can tell by this book's trim waistline, it doesn't take in every morsel offered by the feast we know as Photoshop CS4. And there lies the beauty of what you're holding in your hands right now. Here's why. When you go to a buffet, do you eat everything that's laid out on the seemingly endless buffet table in front of you? My guess is that you don't. You take what you want and leave the rest for others.

In the world of digital imaging, Photoshop is that seemingly endless buffet table. At that table, our host, Adobe, must feed designers, graphic artists, Web producers, special effects technicians, and, oh yeah, photographers too. That's a lot of stuff for a lot of different people. Just as no one's supposed to eat everything at a buffet, you're not required to use every feature of this application. But there are *so many features*, how do you choose the ones you, as a photographer, really need? The *Photoshop CS4 Companion for Photographers* will help you. Think of it as your personal attendant for this event.

It's like you're guided to your own secret version of Photoshop that's just for photographers. The book takes you by the hand and says, "Start with this, then try some of that, but be sure to stay away from those!"

You see, we photographers have kindred spirits within Adobe. I know this because they have bestowed delights upon us, treats hidden within the Photoshop buffet that others won't care about, but that we will relish. We have Photo Downloader, a robust version of Bridge, the powerful Adobe Camera Raw, and some new Photoshop features designed just for shooters. Adobe has built an entire workflow into CS4 that's absolutely incredible. You can do just about *everything* with this application. Take a look at this list of goodies that represents only part of what Photoshop CS4 has to offer:

- Selective downloading of pictures from your memory card. You pick the shots you want.
- Automatic addition of your copyright and other valuable metadata during download.
- Automatic backup of your files to a separate drive during download.
- Simplified sorting, searching, rating, and keywording.
- Virtual collections that can be automated. Your "best shots" collection, for example, can automatically grow as you go about the daily business of rating your images.
- Advanced, nondestructive image editing using tools that photographers understand and actually like.
- Batch processing of your images.
- A simplified approach to using layers in Photoshop.
- Automatic construction of panoramas and high-dynamic-range merges.
- Slide shows, Web albums, and much, much more.

And that's just a taste of what lies ahead for you in this compact guide.

But even though this book is chock-full of helpful information, it's still designed to be portable. Why? More and more photographers are processing their images on laptops. It doesn't make any difference if the device runs Windows or Mac OS X, as long as it fits in your bag. So, you can take your digital darkroom to coffee shops, hotel rooms, commuter trains, airplanes, the patio, and just about anywhere else your knees will fit. That's why you need a book that won't crowd the table but adds to the conversation. This is that book.

Here's how you use the *Photoshop CS4 Companion for Photographers*. First, peruse it from cover to cover, and get to know it. Then read Chapter 1; it's a real ice-breaker, as it's a quick-start guide to the workflow. Move on to the subsequent chapters, which provide detail for each step in the workflow. Then, grab your camera, fill up a memory card, fire up your computer, and get to work.

Q U E S T I O N : What About All Those Other Features that Aren't Covered Here?

Well, my friend Deke McClelland has published his comprehensive *Adobe Photoshop CS4 One-on-One* that takes care of everything else. It's a deep dive, but it's not tailored for photographers, and it's definitely not a book to lug around in your bag.

One last thing I want to mention: It's no mistake that the word *Companion* is part of this book's title. For you, the photographer who wants Photoshop to be a joyous, fulfilling experience, this book is your friend. And I think the two of you are going to have a great time together.

The Quick-Start Road Map

AN OVERVIEW OF THE PHOTOSHOP CS4 WORKFLOW

For many of you, the traditional Photoshop workflow has been to jump in and dig your way out. I want to change that. This story has a beginning, middle, and end. I've designed every step along the way to make your Photoshop experience efficient, productive, and enjoyable. You'll actually feel in control of the software instead of the other way around. In this chapter, I'll provide you with an overview of how this works.

Before I do that, though, I want to share an anecdote. While I was working on this book, I was lucky enough to land an assignment at the Beijing Summer Olympics working in the Main Press Center. My sponsors were Kodak and Apple. My job was to help photographers manage their work in the digital photography lab. I was able to see many beautiful shots as they were transferred from full memory cards to dozens of workstations in the Main Press Center.

I was fascinated by the various workflows photographers had cobbled together over the years. Those using Photoshop as their primary software rarely took advantage of its bundled tools, such as Photo Downloader, Bridge, and Adobe Camera Raw. Instead, they often dragged the contents of their memory cards to the computer desktop and proceeded to open the pictures directly in Photoshop, trying to sort out the shoot from there. Watching these great photographers working under deadline with stacks of Photoshop windows open gave me empathy for their situation. I helped as many of them as I could, but often they were just too stressed to consider a new approach.

I hope *you can* spare a little time to learn about, and embrace, the amazing workflow that Adobe has built into Photoshop CS4. I say with complete confidence that every hour you invest here will save you hundreds of hours in the coming months—time that you can better use to perfect and enjoy your photography. Let's start at the beginning.

Your Digital Darkroom

I like to travel light when I'm on assignment, so my recommendations for an efficient digital darkroom are reasonable:

1. A computer that's less than 2 years old. It can be a desktop version or a laptop, Macintosh or Windows. Performance has improved greatly recently, and you'll need a decent machine for an enjoyable experience.

2. An external hard drive that lets you back up your photos immediately. I recommend at least 500 GB for capacity.

3. A memory card reader. Some desktop computers come with one built in. But you can purchase an external card reader for as little as $20.

4. *Adobe Photoshop CS4.* This application improved greatly for photographers with the CS4 release, and the workflow in this book requires it.

5. *The Photoshop CS4 Companion for Photographers.* This is your guide to digital darkroom happiness.

That's it! These five things are all you need to change your post-production life.

The Basic Steps

One of my favorite moments in photography is when I take the memory card out of my camera, fire up my computer, and insert the card into the card reader. This is when I get my first real view of the work I've done. From that point forward, here's how we'll proceed:

1. Open Bridge and choose Get Photos from Camera. That launches a companion application called Photo Downloader (see Chapter 2).

2. Check your settings in Photo Downloader, choose the images you want to transfer, make sure your backup drive is connected, and download the photos (Chapter 2).

3. Review and rate your pictures in Bridge. Here's where you determine which are your best shots and mark them accordingly (Chapter 3).

4. Add keywords as necessary (Chapter 3).

5. Apply basic image edits to your best shots in Adobe Camera Raw (Chapter 4).

6. Further refine the photos that need additional care with the advanced tools in Adobe Camera Raw (Chapter 5).

7. Move images that require detailed attention in specific areas to Photoshop CS4 for further work. This will be only a small percentage of your shots (Chapter 6).

8. Perform advanced techniques, such as portrait retouching, color changing, and panorama merging, in Photoshop CS4 (Chapter 7).

9. Print some of your work for further evaluation and enjoyment (Chapter 8).

This is the essence of your workflow. You'll be able to process most of your shoots in less than an hour. Yes, this workflow is that efficient!

REMINDER: Launch Photoshop Only When You Need It

You probably noticed that we didn't even launch Photoshop itself until Chapter 6. In large part, that's because Adobe Camera Raw (ACR) is so good at making basic adjustments. Despite its name, ACR is a premier image editor for JPEGs and TIFFs, as well as raw files. So even if you're a JPEG shooter, you can (and should) tap its power.

Let's Get to It!

Now that you've seen the road map, I recommend that you peruse all of the chapters in this book before you make your first download; it'll help you get your bearings. But if you're anxious to get started, and I completely understand why, grab your memory card and turn to Chapter 2.

Importing Your Images

THE POWER OF PHOTO DOWNLOADER

Everyone has to move pictures from their camera to the computer. My question is, "How efficiently are you going to do that?" The theme of this chapter is to work smart so that you can get back behind the lens and take more great shots. The secret to our success is an application that's included in the Photoshop package, called Photo Downloader. Even though you can transfer pictures to your computer in many different ways, most of them aren't as efficient as Photo Downloader.

Photo Downloader is a nifty helper that lets you batch-rename your photos, put them exactly where you want them, and even create backup copies at the same time. These are tasks you'd have to do at one point or another anyway (hopefully!), so why not do them when you first download the pictures?

Here are some of the options you have when you use Photo Downloader:

- Download only the photos you want. You get to preview the images right off the memory card and decide what gets downloaded and what doesn't.

- Generate subfolders to store your pictures in the location you choose.

- Rename files in batches.

- Convert your raw files to DNG as an option if that's a format that you use.

- Back up to a separate hard drive at the time of download.

- Customize metadata and add it to your pictures—important stuff such as author name, copyright, and contact information.

Before You Start Downloading

I know you're champing at the bit to get going, but I have a few tips to make your initiation a pleasant one. First, I highly recommend using a memory card reader instead of connecting your camera to the computer via a USB cable. The biggest issues here are safety and control.

When you take the memory card out of the camera and insert it into a card reader connected to your computer, it appears on your computer as a removable drive. During the downloading process, you don't have to worry about a camera malfunction circumventing the download, or worse yet, corrupting the memory card. Card readers are relatively inexpensive, often less than $30.

Also, have some idea of where you're going to store the pictures that you download. Are you putting them on your computer's hard drive? Will they live on an external drive connected to your computer? Wherever you decide, make sure you have gigabytes of free space to house your burgeoning photo library.

OK, now just a few little foundation-building tasks, and then we'll get to those pictures of yours.

Creating Your Personalized Metadata Template

One of the most powerful features in Photo Downloader is that it lets you apply your personalized metadata during import—important tidbits of text informa-

tion such as your copyright, name, and contact information. The beauty of metadata is that it stays with your photo as it electronically travels out into the world, such as on Web pages or as email attachments. Others can read this information to learn about the image, and more importantly, who originated it. The key to success is to make this an automatic process. I recommend that you set up a metadata template ahead of time so that it's ready when you need it. Then you simply apply it before every import. By doing so, you've transformed a potentially laborious (but important!) task into an automated one.

To create your first template, open Bridge, click Tools, and choose Create Metadata Template from the pop-up menu. The first thing you want to do is give your template a name. I recommend that you label your first template "Basic IPTC." (IPTC stands for International Press Telecommunications Council. That explains a lot, doesn't it? What it means to you is that it is a type of metadata that you can add to your pictures, such as caption and copyright. This is different from EXIF data that your camera adds to the picture, such as capture time and resolution.)

Click the angled triangle to reveal IPTC Core. Find the Creator field and enter your name. When you type a value the checkbox will automatically be selected. Also complete the fields for Creator City, Creator State/Province, Creator Country, Creator Website, Copyright Notice, and Rights Usage Terms. You can also choose other fields if you wish, but these are the basic ones that you should start with. (You can see what mine looks like on the next page.)

Once you've entered all of your information, click Save. If you decide you want to change the information in your template, go back to Bridge, and choose Edit Metadata Template from the Tools menu. You can make any necessary adjustments and save them to your existing template. You can create as many metadata templates as you want. Just be sure to give them descriptive names so that you can tell them apart when you select them in Photo Downloader.

QUESTION: What Should I Put In the Rights Usage Field?

In case you were wondering, a standard phrase you can use for Rights Usage is: "All rights reserved. Written permission required for usage."

These few minutes that you've spent setting up your metadata template will give you a tremendous return on investment. The benefit is that every photo you transfer from your camera will be labeled with your personalized information. You're already ahead of the game.

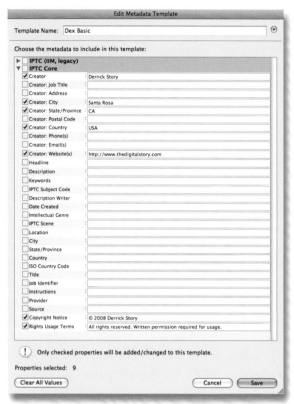

Here's a a basic metadata template

Launching Photo Downloader

You can access Photo Downloader in two basic ways. The first is to set a prefer-
ence in Adobe Bridge to launch the application whenever the camera is con-
nected. To do this, while in Bridge, open Preferences, click the General tab, and
turn on "When a Camera is Connected, Launch Adobe Photo Downloader." Now,
every time you connect your camera or use a memory card reader, Photo Down-
loader will launch and be ready to receive your pictures.

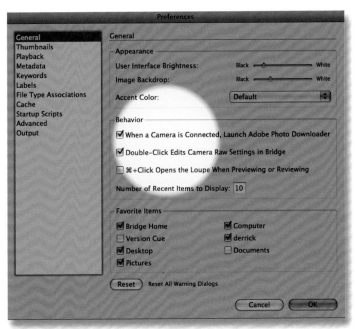

Preference for automatically launching Photo Downloader when your camera is connected

You can also evoke Photo Downloader manually. Once again launch Bridge, click File, and select "Get photos from camera". This summons Photo Downloader for that particular session, but doesn't set it as the default.

TIP: Mac Users Can Keep It in the Dock

Once you've opened Photo Downloader, you'll notice its icon on the Dock. Hold down the Control key and click on the icon to reveal a pop-up menu. Choose Keep in Dock from the pop-up menu to create a shortcut for opening Photo Downloader directly from the Dock. In the future, you won't even have to have Bridge open for this to work.

Time to Choose Your Backup Strategy

One option you'll have in the Photo Downloader dialog box is to back up your images during the transfer process. I highly recommend that you take advantage of this feature.

> **REMINDER:** Images Should Live in at Least Two Places
>
> When you download a memory card of photos to your computer, you have pictures in two places: your hard drive and the memory card. At this point, your memory card is your backup. So you shouldn't format it until you've copied the images to another location.

There are as many approaches to backing up photos as there are photographers. The important thing is that you pick a method for protecting your images against hard-drive failure. One of the easiest methods, and one that I prefer, is to back up your masters during the downloading process. Photo Downloader can automate this process for you.

First, you must consider where you're going to store the backup versions of your photos. The easiest way is to connect an external hard drive that's dedicated to photo archiving. I'm advocating that you set this up right now before download-ing your first batch of images. That way, you'll have the peace of mind that comes with practicing safe photography.

If you shoot raw, you'll want at least a 500-gigabyte drive for backups. But hon-estly, I like 750 GB or more. JPEG shooters don't require as much disk space for their storage, so drives with these capacities will last longer.

If you use the automatic backup feature in Photo Downloader, you will have cre-ated two copies of each picture during the download process. This leaves you free to erase the pictures from your memory card once you've downloaded them. I'll show you exactly how to do this in the following section. In the meantime, procure an external hard drive that you can use for backups In a pinch, you can burn your pictures to DVDs. This isn't as fast as working with hard drives, but if your backup drive fills up, it's nice to have a stash of blank DVDs with you ready for this purpose. Some photographers burn DVDs while they're on the road and mail them back home. That way, if something happens to their equipment, they don't lose all of their shots. Having images always live in two spots is good; three is even better.

But keep in mind that Photo Downloader will need a hard drive for automated backups during transfer. So as lovely as DVDs are, they're in addition to your au-tomated workflow.

THE DROBO ALTERNATIVE TO THE STANDALONE HARD DRIVE

The *Drobo* is labeled as a "Fully Automated SATA Robotic Storage Array," which sounds a little intimidating, like something that will taunt the cat when you're not around. But actually, it's a fairly clever device about the size of a toaster into which you can insert up to four SATA hard drives (like the hard drives inside your desktop computer). After you do this, Drobo takes it from there. It stores any data you write to it, automatically backs it up, and constantly monitors the situation, making necessary adjustments and repairs while you're out doing what you should be doing, taking pictures. You can find out more about the Drobo at *www.drobo.com*.

Importing Photos from Your Camera

Your patience is about to pay off. Now it's time to import a batch of photos. I'm going to walk you through the process step-by-step. What's absolutely wonderful about this stage of the workflow is that it's so darn easy, yet powerful.

Basic Options in Photo Downloader

If you don't have Photo Downloader automatically launching when you connect your camera, open the application now via the File menu in Bridge. Once Photo Downloader is open, it's time to get to work.

Photo Downloader opens with a standard dialog box that I think is rather boring. There are no images! Just dialog box stuff. Most photographers like looking at thumbnails of their pictures, and when you click on the Advanced Dialog button the Photo Downloader dialog box expands to accommodate this. Isn't that better?

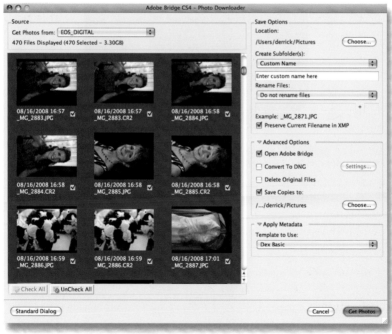

The Advanced Dialog view of Photo Downloader

Take a look at the top of the Photo Downloader interface. You'll see the Source for your images listed. This will either be your camera by name, or the name of

the card in the reader. If you have more than one camera or memory card reader plugged into your computer, all of those sources will be listed in that pop-up menu. But chances are you'll see just the one device you have plugged in at that moment. Beneath the Source you'll see how many files are available, how many megabytes they amount to, and the date stamp.

Below this information are the thumbnails. Each thumbnail will have a date listing and its filename. You'll also notice a box that's checked for each picture. The checkmark means the photo will be downloaded to the computer. If there's an image that you don't want downloaded, simply uncheck its box. You can also uncheck all of the boxes by clicking the UnCheck All button at the bottom of the interface.

You may be thinking, "Why would I open Photo Downloader if I am going to uncheck all the boxes and have nothing to downloaded to my computer?" Well, that's a good question. I think it's a good idea to uncheck all the photos so that you can go back and just check the one or two you want to download instead of having to uncheck 50 or 60 photos. If you decide that you've made a mistake, you can always click the Check All button, and that will check all the thumbnails, bringing you back to where you began.

For the sake of this exercise, let's leave all the checkboxes checked and move on to determining where are our photos are going to be placed on the computer. On the right-hand side of the interface is the Saved Options label at the top of the column. Here is where you get to choose the location for the photos from your memory card. (Remember when I asked you earlier in the chapter to think about where your images are going to reside?) If you leave the default setting, Photo Downloader creates a subfolder in your Pictures folder to place the new images. But you may want to choose a different location, such as another folder on your computer, or even another hard drive. Tell Photo Downloader where you want these pictures to go by clicking Choose (Mac) or Browse (Windows). If you don't have anywhere specific to put these pictures, go ahead and leave the location set to your Pictures folder.

Next you'll see the Create Subfolder option. You have a couple of basic decisions here. If you don't want a subfolder at all, you can select None, and your pictures will be placed within your top level folder. This could be your Pictures folder or another that you've set up. In addition to this, you can direct Photo Downloader to create a unique subfolder too. It's a nice option to help you keep things organized.

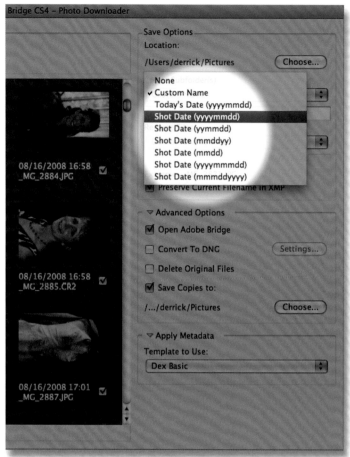

Options for subfolder custom names

Some photographers like to label their subfolders by date. This is also a good approach. Photo Downloader provides you with many different date options. Simply select the date format you prefer, and Photo Downloader will create the appropriate subfolder. The important thing to keep in mind is to always use the same date format in order to avoid confusion up the road.

> **TIP:** Use a Custom Name
>
> Another popular approach is to use the Custom Name option and include the date as part of the folder name. By doing so, photographers can mark their folders with locations or client names.

As you weigh these options, this is probably a good time for a short speech on consistency. "Be consistent!" By doing so, you'll save yourself hours of work down the road when you're trying to find your pictures. That doesn't mean you're forever locked into doing things one way. But be mindful of how you organize your work. You'll thank me later.

RECOMMENDED WORKFLOW

CREATE BRIDGE MASTERS

To manage your folders I suggest you create a top-level folder named "Bridge Masters 2008" on the drive that will house your images. It could be in your Pictures folder on your computer or on an external hard drive. Then, for each shoot, use the Custom Name option to label the subfolder using the format "MM-YY Description."

For example, a subfolder for the Beijing Olympics would be "08-08 Beijing Olympics." So an example of the path would be [External hard drive]→Bridge Masters 2008→0808 Beijing Olympics→Individual photos.

You'll see how this system plays out nicely in Chapter 3.

Another handy feature in Photo Downloader is its ability to rename files during import. This function is sometimes called "batch rename" in other applications. Here, it's called "Rename Files." I like it because cameras tend to name photos with dull filenames such as IMG_4732.JPG. Using the "Rename Files" feature, you can give your photos more descriptive labels, thereby creating another valuable piece of metadata on import. Some of the options for renaming files include today's date, the date of the shoot, a custom name, or a custom name plus date.

Unfortunately, Photo Downloader doesn't include my favorite way for renaming files. I like to use "custom name" plus original file number. What's so great about that? Well, the original file number that the camera assigns is something that I like to hang on to for tracking purposes, but I also want a text descriptor. So, by adding "custom name," I can have "Hawaii_5062.cr2" instead of "Img_5062.cr2."

For my work, I'm going to choose "Do not rename files" from the pop-up menu. And instead, I'm going to rename my files later in Bridge using its more powerful "Batch Rename" function under the Tools menu. But you may feel differently. The real takeaway is that you have one option here, and I'll discuss what else you can do later in Bridge also. Then you decide.

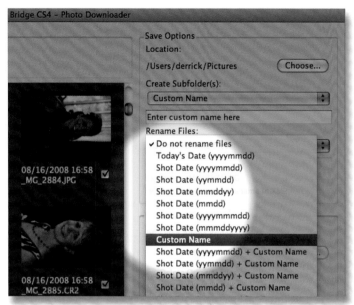

Options for file renaming in Photo Downloader

If you do use Rename Files, you may want to check the box next to "Preserve Current File Name in XMP." By doing so, you can always see the original filename in the metadata pane in Bridge under File Properties→Preserved File Name.

Advanced Photo Downloader Options

Photo Downloader provides some very handy advanced options that further streamline your workflow. For example, you can save a step by having Photo Downloader open Bridge to browse the photos you just downloaded. Another option is to automatically convert your raw files to DNG.

DNG is shorthand for "digital negative." It's an open file format Adobe created to help standardize the various proprietary raw formats created by camera manufacturers. The thinking is that since DNG is an open format, the developer com-

munity will always support it. Therefore, photographers won't run the risk of losing access to their files if camera manufacturers no longer support the proprietary raw files.

Whether you choose to use DNG or not is a personal matter. I think it's unlikely that camera manufacturers will stop supporting most major raw formats. But others disagree. So in the end, whether you convert to DNG is up to you.

One of my favorite arguments for using DNGs has nothing to do with proprietary raw formats. I like that the picture metadata is stored inside the DNG container, getting rid of those pesky XMP sidecar files rattling around in your pictures folder.

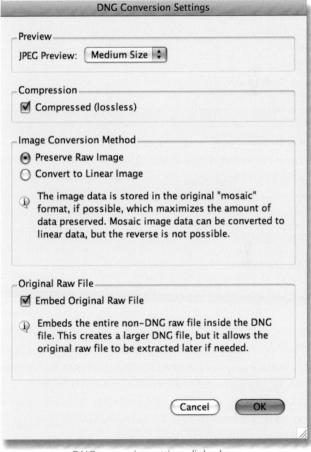

DNG conversion settings dialog box

I think JPEG previews are handy, and so I recommend choosing either full-size or medium depending on your preferences. As for compression, since it's lossless anyway, I like to save a little bit on my file size, so I always turn on the Compressed box. And finally, as for the Image Conversion Method, I recommend selecting Preserve Raw Image. This method maximizes the amount of data preserved for the original file. You may want to embed the original raw file into your DNG. The advantage to this approach is that you can extract the raw file from the DNG container later, if necessary. This does create a larger DNG file, however. Then click OK to close the DNG Conversion Settings dialog box.

The next option to consider is Delete Original Files. If you check this box, Photo Downloader will remove the pictures from your memory card or camera after download. I don't recommend using this option. I think it's better to make sure that your pictures have downloaded properly, and that they are backed up, before removing them from the memory card. Plus, I prefer using the format option on my digital camera for formatting the memory card. That way, I know the card is totally compatible with the camera.

> **Q U E S T I O N :** What Happens If I Shoot RAW+JPEG?
>
> Many cameras that capture in raw provide a RAW+JPEG option. This is handy for photographers who need to grab processed images right off the card and want raws for processing later. If you shoot in these formats, Photo Downloader will download both and place them side by side in Bridge. And if you check "Convert to DNG," Photo Downloader converts the raw files to DNG and leaves the JPEGs alone.

The final option, however, is a good one, and I highly recommend it. By checking "Save Copies to", you can automatically back up your pictures to a separate hard drive during the downloading process.

The most common approach is to purchase an external FireWire drive, plug it into your computer, and use it for image backups. Simply click Choose (Mac) or Browse (Windows) to direct Photo Downloader to your backup drive. Photo Downloader won't create a subfolder for you the way it does for the primary file downloads, so you have to create this first before you initiate the download, and then direct Photo Downloader to it. But the upshot is that you do get an automated backup without much effort.

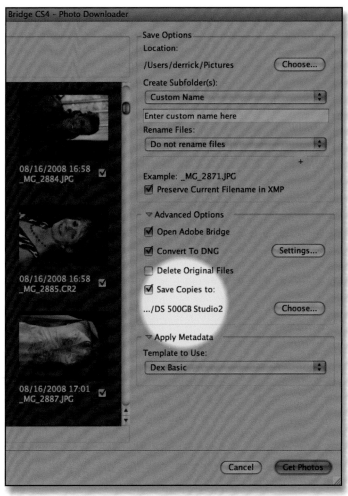

A hard drive selected to receive backup images

Mac users can create subfolders on the fly using the New Folder button in the Choose dialog box. In Photo Downloader, click Choose to the right of "Save Copies to." Navigate to your backup hard drive, and then click New Folder to create the name for the backup subfolder. Now click Choose, and you're all set. On Windows, simply click the Make New Folder button. The new folder will be called "New Folder" and will be in edit mode so that you can type a new name and press Enter.

T I P : DNG and Raw Files on One Download—Oh My!

If you can't decide whether you should choose DNG or your original raw files when copying your files off the memory card, you can do both. That's right. In Photo Downloader's Advanced Options menu, turn on the boxes for "Convert to DNG" and "Save Copies to." Downloader converts the primary files to DNG, but leaves the backups in their original state. So, you have DNGs to work with on your computer, but you always have the original raw files available on the backup drive.

Applying Metadata During Download

Earlier in this chapter, I discussed how to set up a metadata template. Now you're going to reap the benefits from the work you did earlier. In the Apply Metadata section of Photo Downloader, you have three basic options.

First, you can skip applying any metadata whatsoever by selecting None from the pop-up menu. But why miss an opportunity to add information to your photos automatically? So, if you do nothing else, at least choose Basic Metadata from the pop-up menu and fill in the Creator and Copyright fields. That way, all of your photos will at least have your name and copyright information in the IPTC information.

This means that if someone else stumbles across your photo—on the Web, via email, or through any other electronic method—they can find out who took the photo and who owns the copyright. (You never know when someone may want to buy one of your pictures. So, make it easy for people to find you.)

But you can take this a step further by creating your own metadata template that I showed you earlier. Then, not only can you include the Creator and Copyright fields, but also you can add your contact information directly to the file header of your photograph or embedded in the DNG file. That way, anyone who wants to find you for permission to use your photo or (better yet) buy it can do so easily. If you've created one, your custom metadata template will appear in this pop-up menu. And all of the information you included in that template will be applied to the photos during download.

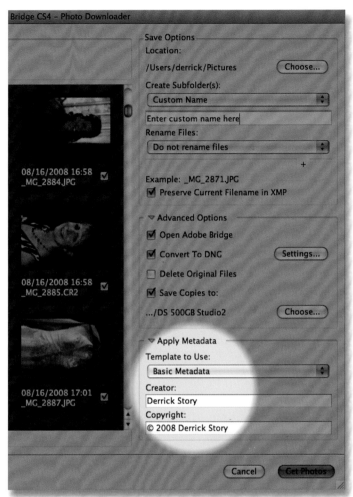

Basic metadata fields in Photo Downloader

REMINDER: Apply the Bare Minimum at Least

Add at least Creator and Copyright information to every photo you download to your computer. That's my recommendation for the bare minimum applied metadata.

QUESTION: What Are Those Extra Files?

If you shoot raw files, and you apply metadata during the downloading process, you'll see an extra set of files in your Pictures folder. The file extension will be *.xmp*. These are so-called "sidecar" files that contain metadata that accompany your raw files. Bridge and other photo management applications will read these sidecar files when you open their respective photographs and display the metadata as needed. The only thing you'll to keep in mind is that you want to keep the sidecar files in the same folder as the pictures that go with them. That way, the photo application has access to all the information it needs. If you don't like sidecar files, you can always convert your raw files to DNG and have the metadata live inside the container.

Where to Go from Here

You've taken a great step forward toward organizing your photographs. If you followed the steps I outlined in this chapter, your images are stored in a dedicated location, organized in subfolders, and even backed up. This makes it much easier for you to work with your pictures later as you move through the workflow. In the next chapter, I'll tackle how to efficiently rate your images and propose more efficiencies to make your photographic life happy and carefree.

Rating and Keywording Images

PHOTO EDITING IN BRIDGE

Over the years, Adobe has quietly been adding tools to Photoshop to help photographers organize their work. In Chapter 2, you saw how Photo Downloader efficiently moves pictures from your memory card to your computer. In this chapter, I'll show you how Bridge, a sophisticated image browser, has evolved into an important photo management tool.

What is photo management? Basically, it involves everything you do to a photo except image adjustment and output. And that's a big part of photography these days. You have hundreds, if not thousands, of pictures on your hard drive. Can you quickly retrieve the one shot you're looking for? Do you know which in a series of eight images is the sharpest? You will after embracing the techniques I'm about to explain.

The flow is quite simple. You move your images from your camera to your computer using Photo Downloader, and then let that application hand off the newly added images to Bridge for organization. I must confess that I love this stage of the flow. Here's where I first get to enjoy looking at my images, and at the same time I'm organizing them so that I know my best shots from the average ones. And if that wasn't good enough, I can quickly add keywords to make it even easier to find a particular shot at a later date. All of this happens in one seamless flow of events that takes less time than you would have previously imagined.

I never thought I'd be excited about anything that involved "getting organized." But I hope that by the time you finish working with the techniques in this chapter, you'll be just as thrilled about viewing, rating, and organizing your images as I've become. You may even look forward to this stage of the photographic process. So, let's get started!

Setting Up Your Workspaces

Before you actually begin working with your pictures, you should to set up your workspaces. You have to do this only once, and then your workspaces are available to you every time you open Bridge. Your return on investment will be tremendous over time.

This is probably the point where you're thinking to yourself, "That's great, but what's a workspace?" I'm glad you asked. Bridge has all sorts of helpful tools, such as collections, filters, thumbnails, a filmstrip, file properties, a Keywords pane, and more. Depending on your task, you may want to arrange these tools in a certain way, or even hide some of them altogether. An arrangement of these tools is called a *workspace*.

Bridge starts you out with some basic workspaces. You can find them by selecting Window→Workspace. These built-in workspaces are actually quite handy, but as you begin to customize your workflow, you'll want to create custom workspaces too. I'm going to help you get a head start on this process by assisting you in setting up the three basic workspaces that you'll need to work efficiently.

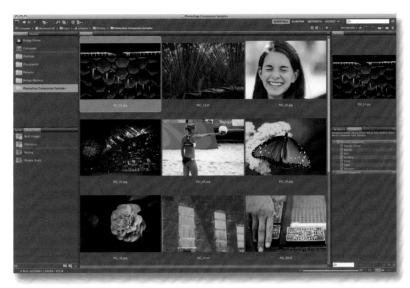

The Bridge Essentials workspace. You can adjust the preloaded workspaces in Bridge to meet the needs of your own organizational flow.

REMINDER: Invest in Custom Workspaces

Set up custom workspaces in Bridge that represent the stages of your organizational workflow. They'll help you stay on track and not skip important steps.

These workspaces represent the three stages of your organizational flow. The first workspace is called "Overview," the second "Photo Edit," and the third, "Keywording."

The Overview workspace is where you get a good look at your thumbnails, where they live on your computer, and their basic metadata, all in one attractive view. The Photo Edit workspace is designed to make it easier for you to rank your photos. You'll do that by adding star ratings to your favorite shots. And finally, the Keywording workspace is designed to make it amazingly easy to tag your photos for trouble-free retrieval later.

To create your first custom workspace, open Bridge and then click Window at the top of the interface. The Workspace flyout menu appears. You'll see that Adobe provides some basic workspaces for you. You're going to choose a couple of those workspaces, customize them, and then rename them.

Creating the Overview Workspace

The Overview workspace will be your "home" in Bridge. Start by selecting the built-in Essentials workspace from the Workspace flyout menu. The Bridge interface is now divided into three basic areas. At the top left is the legend for where your pictures are located. Click the Favorites tab, and you should see icons for Bridge Home, Computer, Pictures, and so on.

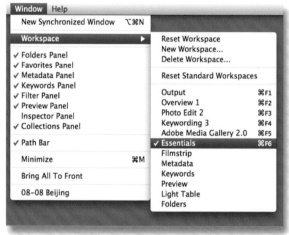

Start by choosing the Essentials workspace in Bridge.

The first step in customizing this workspace is to create a shortcut in this column for the place where Photo Downloader has stored your pictures, the Bridge Masters folder you created in the previous chapter.

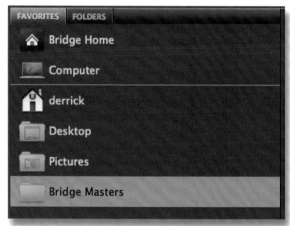

Adding Bridge Masters to your Favorites

Click your Pictures folder to reveal its contents. In there, if you've followed Recommended Workflow, you should have a folder labeled Bridge Masters. Drag that folder to the left column so that it becomes part of your Favorites list. Now click the Bridge Masters folder, and you should see all the folders (filled with photos) that you added to your computer using Photo Downloader. You can control how big the folders appear in this workspace by moving the thumbnail slider in the lower right-hand corner of the Bridge interface. I usually like to make the folders a little bigger in size than what Bridge originally presents to me. If you double-click one of those folders, Bridge will show you the thumbnails contained inside. Very nice!

TIP: Know Where You Are

Here's a new goodie that I think you'll like. Go back to the Window pop-up menu at the top of the interface and make sure Path Bar is selected. This is a very helpful addition to Bridge because it shows you the hierarchical path to where all of your pictures are located, so you can see exactly where everything lives on your hard drive in one simple view.

> Computer > Dex MBP 200GB > Users > derrick > Pictures > Bridge Masters 2008 > 08

The Path Bar shows you the exact location of your files on your hard drive.

But wait, we have more to explore. Going back to the left-hand column, you have another area below Favorites. In this space, click the Collections tab. At the moment, you won't have anything in this area, but you're going to change that soon. (I'll give you a hint: Collections are one of the coolest new features in Bridge CS4. Stay tuned.)

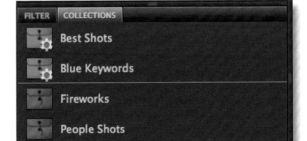

A sneak peek at the Collections tab with manually created Collections (brown folders) and Smart Collections (blue folders)

Now turn your attention to the center area where your thumbnails are displayed. This is called the Content space. Just as you can with folders, you can make thumbnails larger or smaller by using the sizing slider in the lower right-hand corner of the interface. Play around with the thumbnail slider until the images are displayed the way you like.

Use the thumbnail slider to display your images at a comfortable size.

Finally, take a look at the right-hand column. Bridge, in its default configuration, allocates the top area of that column for previews. For your current purposes, you don't need that. So, go back to the Window menu at the top of the interface and make sure the Preview Panel option is not turned on.

At this point, you'll have two tabs at the top of the right-hand column: Metadata and Keywords. Click the Metadata tab. Here's where you'll review the core metadata for your images, including File Properties, IPTC Core, Camera Data (EXIF), and Camera Raw. Since Bridge will list all of the fields possible in this area, it's worth a quick side trip to the Preferences dialog box to trim this list so that it displays only the fields that interest you. Yes, you must tame the metadata beast now, or it'll torment you forever.

Once you've selected the fields you want displayed, turn on the Hide Empty Fields and Show Metadata Placard checkboxes. Now all you have to do is click OK, and you've tamed the metadata display beast!

RECOMMENDED WORKFLOW

SUGGESTED METADATA FIELDS

In its default configuration, Bridge displays more metadata fields than most people need. I have a list of suggested fields to activate that will help keep your list tidy and free from items you don't need. To make your selections, go to Bridge CS4 on the top menu bar and choose Preferences from the pop-up menu (via Edit→Preferences in Windows). Then click the Metadata option in the right-hand column of the dialog box to reveal all of the field options. Start with File Properties and work your way down. Here are the fields I recommend you display. Just turn on the checkboxes next to these items.

The Metadata Preferences Tab and my recommendations for which fields you might want to display.

Your first workspace is now ready for you to save. Go back to Window, mouse over Workspace, and select New Workspace from the flyout menu. Bridge will ask you to name the workspace. Enter "Overview 1" in the Name field. (Adding the number is optional. I included it here as a reminder for the steps in the workflow.) Turn on both the Save Window Location as Part of Workspace and Save Sort Order as Part of Workspace checkboxes beneath the label, and then click Save. Bridge has now added your workspace to the list of default workspaces, and it has added your custom workspace to the top of the interface to the left of the search box. This is a very handy shortcut that'll save you from having to navigate the menu system when you want to change workspaces. OK, one down, a couple more to go. The second two setups will go much more quickly.

The shortcut to your Overview 1 workspace appears at the top of the window.

Creating the Photo Edit Workspace

The next workspace you're going to create is one you'll use for rating your photos. You can use the Overview workspace to rate your photos if you want, but I think it's hard to judge picture quality by looking at a thumbnail. I'd much rather look at an enlargement before deciding which shots are best. By creating a view that provides a very large preview, you'll be able to maximize the screen area for each photo before you assign a rating.

Go back to the Window pop-up menu and choose Filmstrip from the Workspace flyout if you want your thumbnails to appear below enlarged versions of the images, or Preview if you want the thumbnails displayed to the side of the images. You'll notice that this is a completely different look compared to your Overview 1 workspace. You still have a left-hand column showing your Favorites, but everything else is a picture. This is very helpful for focusing your attention on the image itself without the distraction of metadata.

The only adjustment you have to make to the left-hand column is to click the Collections tab to activate that panel. Now move to the Preview area. If you click on a thumbnail in the Content filmstrip, you'll get a nice, healthy, enlarged view of your photo in the Preview pane. You can adjust the size of this picture by dragging up or down the center of the divider that separates the Preview pane from the Content pane.

I like a nice, large Preview pane. I think it makes it easier to judge the quality of a photo. And that's exactly what you're going to use this workspace for. Once you have everything proportionally the way you like, go back to New Workspace and save this workspace as "Photo Edit 2". You're now two-thirds of the way through setting up your work area.

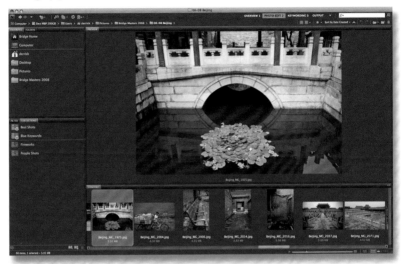

The Photo Edit 2 workspace provides you with a generous view of your images so that you can more easily rate them.

QUESTION: What is the Difference Between Photo Editing and Image Editing?

As I'll explain in greater detail later, *photo editing* is sorting your pictures to determine the best ones. *Image editing* is changing the pixels to improve the tone, contrast, and so on, of an image.

Setting Up the Keywording Workspace

Keywording is an important part of your workflow. Many photographers don't apply keywords to their images because they don't have an efficient system for doing so. Quite frankly, if a task feels like drudgery, we probably won't do it. So, the trick here is to set up a workspace that makes keywording more enjoyable. By doing so, you may actually add keywords to your photos.

Go back to Window, and choose Overview 1 from the Workspace flyout menu. This is the workspace that you created earlier. We're going to make a few adjustments to it, and then save it as our keywording area.

Your left-hand column should be in good shape, so you don't have to do anything there. In the center Content area, you may want to adjust the size of the thumbnails for keywording. I usually like the thumbnails a little smaller for this activity, because I tend to choose a lot of pictures at once and apply keywords to them. So, use the thumbnail slider at the bottom of the interface to adjust the size of your pictures. Then, in the right-hand column, click the Keywords tab. This reveals some basic keywords that Adobe provides for you. But you'll be adding your own very soon.

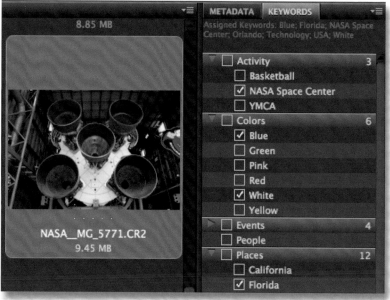

Adding keywords to an image can be as simple as selecting a box; more on that later in this chapter.

Once again, go to New Workspace and label this work area as "Keywording 3". You're now ready to start working with your pictures.

Organizing Your First Batch of Images

The big moment is here. You're now going to begin working with your pictures and taking advantage of all of this foundation work you've done. If you haven't downloaded pictures to your computer yet using Photo Downloader, now is the time to do so (I cover using Photo Downloader in Chapter 2), because you're going to start working with actual photographs.

The first time through, I'd like you to follow these instructions as closely as possible. Down the road, you'll surely develop your own variations, but for now, it's important that you get a feel for this flow from start to finish. One of the biggest traps that people fall into is that they stop to admire their work, start playing with a picture or two, and never complete the process. I totally understand that. But I promise you that the process we'll use here provides lots of time to play with pictures. After all, isn't that what it's all about?

Step 1: Reviewing Your Shots in the Overview Workspace

The first thing I want you to do after you download a shoot is to take a quick peek at your images in the Overview workspace. Click a thumbnail, and then look in the right-hand column under Camera Data to check your ISO setting, exposure, and white balance. You're looking for surprises. For example, if you were shooting landscape pictures with your ISO accidentally set to 1600, you would know that the image quality of those shots would be compromised. A high ISO setting is great for low-light interiors, but it's not so good for fine-art landscapes because you'll have to endure more image noise and less saturated colors.

> **TIP:** Browse Images Via List View
>
> You can manage large quantities of photos easily by working in List view which you can choose by going to the View menu and choosing As List. In this view, you can see more files at once and sort by Name, Date Created, Size, Type, Rating and so on, plus you still have access to all of the filters such as Aperture setting and Exposure time.

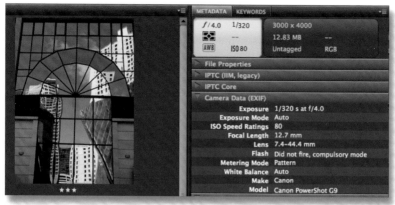

Look for EXIF data that provides insights into your photos, such as ISO rating, shutter speed, aperture, and white balance.

By quickly surveying the camera data settings, you'll be able to identify any basic mistakes you made which would prevent you from giving images a top rating later on. The easiest way to move from thumbnail to thumbnail during this survey is to use the right and left arrow keys. If everything looks good, you're ready to move to the next phase.

TIP: Performance Boost While Displaying Images

When you've just downloaded hundreds of images into Bridge, you can speed up viewing performance by adjusting the quality level that Bridge uses for generating. These options are available via the square icon next to the star icon in the upper right corner of the Bridge interface. By switching to "Prefer embedded," your image browsing will become snappier. When you're ready for more image quality, change the setting to "High Quality on Demand" and "Always High Quality" as appropriate.

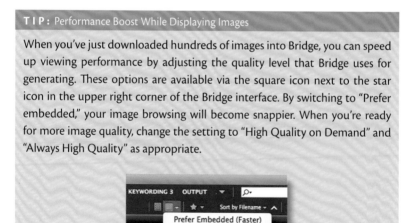

Step 2: Photo Editing: Sorting Your Pictures

The next phase of this workflow is photo editing. Photo editing is very different from image editing, and the two are often confused. Image editing is the process of actually changing the pixels of an image; that is, making adjustments such as color temperature, contrast, and exposure. Photo editing is the process of ranking your pictures from strongest to weakest.

Photo editing's roots lie in the film photography days when photographers would spread out a box of slides on a light table and examine each one with a magnifying loupe. Often they'd devise some sort of rating system so that they could remember the best slides from the worst. I often used a felt-tipped pen and marked my best shots with three dots and my average shots with two dots, leaving the rest of my shots unmarked.

On the first pass, rate any image worth keeping with two stars.
You can refine your ratings on the second pass.

Photo editing in Bridge is not much different, but it is a lot more fun. I'm going to show you a two-step process that'll help you quickly evaluate all the photos from a given shoot. To start, open a folder of photos and switch to your Photo Edit 2 workspace. Yes, that would be the one you created earlier.

Round 1: Basic Thumbs Up or Down

At the bottom of the Photo Edit workspace is a film strip displaying thumbnails and a large preview. Each time you move to a new thumbnail, you see an enlarged version of it in the Preview pane. As you look at each photo the first time through, you'll assign a two-star rating to any image that you consider acceptable. This should go very quickly. Don't do anything else at this point.

To assign a rating, simply hold down the combination of the ⌘ key (the Ctrl key in Windows) and the number that you want to rate your image. For example, ⌘-2 (Ctrl-2) would produce a two-star rating for the image. You can see the rating listed beneath the preview version of the photograph. After you rate the first photo, press the right arrow key on the keyboard to move to the next thumbnail. Either rate it if it's an acceptable image, or skip it if it's not a quality photograph.

Here's how I usually do this. I use my left hand to rate the photos and my right hand to operate the arrow keys. I can go through a batch of photos in just a few minutes. Once you finish this first pass through, you'll have identified your acceptable photographs from those that are below par.

> **QUESTION:** Should I Delete My Below-Par Images?
>
> People always ask me whether they should discard the images that didn't receive a rating. My philosophy is to hang on to them, with the possible exception of images that just have no value whatsoever, such as those that are completely black, are hopelessly out of focus, or in which your thumb covered the lens. But if it's just a below-par image that is the weakest of the bunch, I usually hang on to it just in case I need it for some unknown reason in the future. The final decision is up to you. The important thing is that you identify your acceptable photos, and then go to the second phase of the rating process.

Round 2: Refining Your Ratings

Once you've finished the first pass through, you want to separate the images with two stars from those with none. First, return to the Overview 1 workspace so that you're dealing with thumbnails during the sorting phase. Next, separate your two-star images from those that aren't rated. One way to do that is to click the "Sort by" pop-up menu at the top of the Bridge interface. Generally speaking, the default is "by date created." But for the moment, you're going to change that selection to "by rating." When you do this, all of the images with star ratings will

be grouped together. Select them all by clicking once on the first thumbnail with a rating, holding down the Shift key, and then clicking the last thumbnail in the sequence with a rating. All of the rated images will now be selected.

A second way to choose all of the two-star images is to click the Filter tab that is next to the Collections tab on the left side of the Bridge interface. Under Ratings you'll see the icon for two stars with the number of images listed that received that rating. If you click the stars, Bridge will filter out the images with no rating and let you easily select the rated images by clicking Select All (⌘-A or Ctrl-A).

Choose the approach that works best for you. At this point, you should have all of your two-star images selected.

Here's where you get to use a new feature in Bridge CS4. The lower pane of the left-hand column is labeled Collections. Collections are like virtual photo albums that you can create on the fly. Your pictures still live in the primary folders you created when you downloaded them, but now you can play with virtual copies of them by creating a collection. This is very handy for rating your pictures and performing other activities.

Right now, you're going to create a temporary collection of your star-rated photos so that you can focus on your best shots. Click the New Collection icon at the bottom of the Collections pane. It looks like a little briefcase with a plus sign. Bridge will ask you whether you want to include the selected files in this new collection. Click Yes.

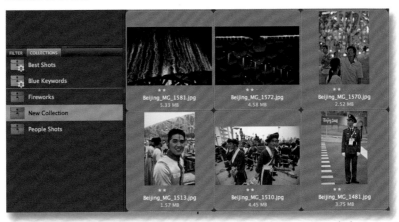

By creating a collection, you have a virtual work area for your starred photos.

A new Collection icon will appear in the left-hand pane. Give it a name that identifies its contents. Now go back to the "Sort by" pop-up menu and choose By

Date Created. Return to the Photo Edit 2 workspace. You're now ready to give your photos their final ratings.

During this round you're going to promote your best images by giving them a higher star rating. The process is simple. You go through your batch of two-star images and increase the rating of those pictures that you think are the best shots. I like to do this in two passes because I need to see the entire shoot once before I have a "feel" for which shots are superior. So, go through your two-star images again, and increase to three stars the rating of the photos which are better than "acceptable." If you come across a really great shot, possibly the best of the entire shoot, give it four or five stars. If you're not particularly moved by the image as you look at it this second time, just leave its rating at two stars.

Within a few minutes, you will have identified the best images from your shoot. Plus, as I promised, you were able to enjoy your images while you rated them.

Rating and Sorting Tips

Over time, you'll become very efficient at rating photos. To help you reach that point even more quickly, here are some techniques that I think you'll enjoy.

Tricks for Comparing Two Photos

If you have two photos that appear to be identical in quality, I have a neat trick that'll help you determine which one is better. Click the first candidate once, hold down the ⌘ key (Ctrl in Windows), and then click the second candidate. The two images will appear side by side in the Preview pane. This will make it easier for you to judge them.

But it gets better. You'll notice that if you move your mouse over any area of the image, your cursor turns into a magnifying glass with a plus sign. Click once, and that activates the loupe. You can drag the loupe around the picture, inspecting its various parts at 100 percent magnification. This makes it much easier to evaluate the fine detail of the photograph. Now move your mouse over to the second photograph and click the same area that you were inspecting in the first. You'll get a second loupe specifically for that photograph.

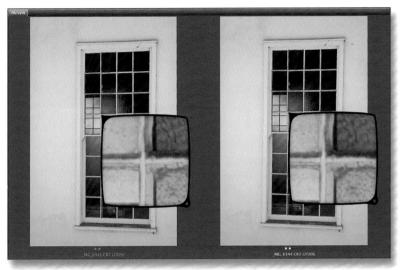

Side-by-side photos, each with their own loupe for making comparisons

But here's the really cool part. Hold down the ⌘ key (Ctrl on Windows) and move either one of the loupes. They'll move in tandem, giving you a 100 percent comparison of the same areas of each photograph. Now you really have some detailed information to inform your rating decision. Once you've decided which image is better, hide the loupe by clicking once inside its magnifying glass, then click the thumbnail of the image that you want to re-rank and increase its rating.

But wait, there's more. If you want an enlarged view of the entire photo and you don't feel like leaving the comfy confines of your well-organized workspace, simply click the thumbnail and press the spacebar. Bridge will present you with a full-screen version of your image, letting you inspect it more easily. Want a closer look? Click once in the image to view it at 100 percent. Hold down the mouse button and drag and you can navigate around the image at full resolution.

Once you've finished your review, simply press the spacebar again, and the photo will return to its thumbnail-size view. How fun was that?

REMINDER: Why You're Bothering to Identify Your Best Images

It only takes a few minutes to find your best shots, but doing image editing work on pictures can take hours. That's time you want to spend only on your best work.

QUICK SORTING VIA REVIEW MODE

When you need to work really fast (promising yourself that you'll come back later to star-rate your images), you can take advantage of the new Review Mode in Bridge. Think of this as sorting on steroids.

1. Double-click on the folder of photos that you wish to cull. This should open them in thumbnail mode.

2. Enter Review Mode by going to View→Review Mode or pressing ⌘/CTRL-B.

3. You'll see your images displayed in carousel fashion. Use the right and left arrows to move from one image to the next.

4. When you see a photo that you don't like, press the down arrow key. Bridge removes the image from the carousel (but it stays on your hard drive).

5. Once you've whittled down the batch to the images you like, press the "Collection from Review Mode" icon in the lower-right corner.

6. You'll be asked to name this new collection.

7. Your "picks" will be gathered together into a new collection and listed under the Collections tab.

Once you have your collection assembled, you can adjust the pictures, add metadata, or output to PDF or the Web. This is a virtual collection, so all of the work you do will also be reflected in the original folder of images.

Using Smart Collections

Another terrific new feature in Bridge CS4 is Smart Collections. Collections let you group images across folders, and Smart Collections will do so automatically. Essentially, Smart Collections are specialized search folders that let you apply specific criteria. Then, as those criteria are met, images are automatically added to the Smart Collection. One of my favorite uses for this function is to create a folder of my best photographs. And since I'm identifying my superior shots with high star ratings, I can have a Smart Collection automatically gather those images.

To create a Smart Collection, click the New Smart Collection icon at the bottom of the Collections pane. It looks like a little briefcase with a gear. The Smart Collection dialog box will open where you can fine-tune your search criteria. For the source, select Bridge Masters, since that's where you're storing all your photos. For Criteria, choose Rating in the left-hand pop-up menu. Next, choose "is greater than" in the middle pop-up menu. And finally, select the three-star rating in the right-hand pop-up menu. Under Results, in the Match pop-up menu, select "If any criteria are met". Then go ahead and turn on the Include All Subfolders checkbox. Now click Save.

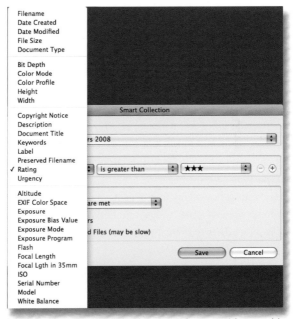

The Smart Collection dialog box provides you with a wealth of criteria on which to search your images.

Bridge will create a new Smart Collection for you, and will place within it all of your images that have four stars or more . . . automatically! Now, every time you rate a photo as four stars or more, it will appear in this Smart Collection. This is a great way to always have your best shots at your fingertips, no matter where the originals live.

RAW+JPEG

Photographers who like to capture in both raw and JPEG at the same time will see duplicates of each shot when rating them in Bridge. Even though assigning star ratings to photographs is fun, nobody wants to deal with twice as many photos as necessary. Bridge has a nifty tool, however, that deals with this problem.

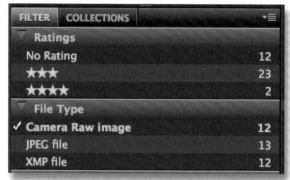

You can filter your collection of raws and JPEGs to display just one type or the other. This also works if you want to filter out XMP sidecar files that may appear in your collection.

While you're working in your Photo Edit 2 workspace, revisit the left-side panel. Next to the Collections tab is the Filters tab; click it. One of the criteria under the Filters tab is File Type. In the Filter pane are labels for both raw and JPEG, with a number representing how many files of each you have in that folder. I recommend that you spend your time reading and keywording the raw files, and just leave the JPEGs alone. They're there if you need them, but I don't see any reason to invest a lot of time working on them.

So, under File Type, click Camera Raw Image. Bridge will show you all of your raw files, and will temporarily hide the JPEGs from view. If you want to remove the filter, just click Camera Raw Image again. But I recommend that you leave the filter on while you rate and keyword your images. Now, click the Collections tab, and get back to work.

Introduction to Keywording

I'm sure you've been told at least once that you should add keywords to your images. But why? The bottom line is that it will help you find them later on. And I'm going to show you how.

I'll start by highlighting the excellent tools Bridge has for retrieving and sorting your images using keywords. My hope is that you'll be so enthused about this power that you'll happily spend a minute or two adding keywords to your pictures after you've finished rating them. Let's see how motivating I can be.

Tools for Searching by Keywords

Bridge provides two handy tools to help you find images via keywords. The first is the Search window in the upper-left corner of the interface, and the second is Smart Collections.

Using Search couldn't be easier. Click once on your Bridge Masters folder in the Favorites panel to highlight it. Now enter your search term in the Search field in the upper-right corner of the Bridge interface and press the Return key. If there are results, Bridge will display them in the Content pane.

Note the search word in the upper-right corner and
the results display in the Content pane.

By clicking the magnifying glass icon in the Search field, you can select different ways to perform your hunt. Generally speaking, the Search feature in Bridge will get the job done nicely.

Another approach is to use the Find dialog box. In the Edit pop-up menu, at the top of the Search window, choose Find. Bridge provides you with a dialog box that lets you customize your search based on source and criteria. Bridge will also display these results in the Content pane.

If you want to keep your search results for future reference, you may want to use the Smart Collections approach. Click the Smart Collections icon at the bottom of the Collections pane, and then set your source and criteria in the pane's dialog box. Bridge will put the search results in a new Smart Collection. One thing I like about this approach is that as new images meet the criteria, they'll automatically be added to this Collection. These search tools help you quickly find images via their keywords. So, now the trick is, how easily can you add those helpful keywords?

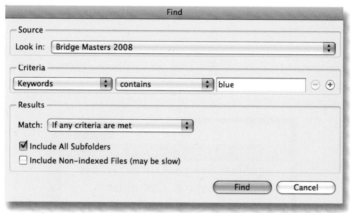

The Find dialog box provides a wide array of search criteria.

Adding Keywords to Your Images

You've already designed your Keywording 3 workspace. Now, click it and let's put it to use. Open a batch of photos. In the right-hand pane, you'll have a few preliminary keywords that probably won't be of much use to you. That's OK. They're simply examples. What you want to do is create your own batch of keywords tailored to your images.

Bridge lets you create a top-level term, such as *Events*, and then add subkeywords, such as *birthday*, *family gathering*, *wedding*, and so on. Each keyword has a box next to it. To apply a keyword to a photo or group of photos, simply select the relevant images and then turn on the keyword box. That's it!

To create a top-level keyword, click the plus icon at the bottom of the Keywords pane. To add a subkeyword, make sure your top-level term is selected and then click the smaller plus icon to the left of the bigger plus icon. One of the conveniences of building your list this way is that you can collapse the subkeywords by clicking the triangle icon to the left of the top-level keyword. This helps save space as your keyword list grows. Top-level categories to consider include activities, colors, events, people, places, things, and time of day.

I start the keywording process by selecting all of the images in the shoot (using Select All) and applying broad keywords such as *country*, *state*, and *city*. These are very helpful labels. Think about it. If you know the approximate date and location of a shot you're looking for, you can find it in seconds by just using these simple keywords.

I then deselect all of the images (by clicking Deselect All in the Edit pop-up menu), and choose small groups of pictures so that I can apply more specific keywords, such as *activity*, *colors*, *people*, and *things*. The whole process should take only a few minutes. You've now accomplished a great deal of organizational work in a very short time.

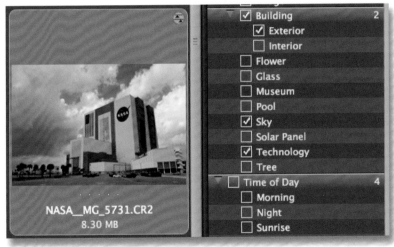

A sample Keywords pane with subkeywords

Right-clicking a keyword presents a whole menu of options, including New Keyword, New Sub Keyword, Rename, and Delete. And just in case you were wondering, yes, you can create an additional subkeyword for an existing subkeyword.

RECOMMENDED WORKFLOW

YOU SHOULD BACK UP YOUR WORK, TOO

When you follow my recommendations in Chapter 2, your raw *files* may be backed up, but not the metadata that goes with them. Although your photos may seem like your primary concern, the metadata is important too because it represents significant work you've invested in your images (ratings, keywords, etc.).

If you add metadata on import as I've suggested, Photo Downloader creates an XMP file that accompanies each raw file. That XMP file contains your basic user information such as author name and copyright. As your continue to work with your raw files in Bridge by rating them and adding keywords, that information is also added to the XMP file. Over time, this can represent a lot of your labor. I recommend that you back up those XMP files and keep a copy of them with the original images (in their separate folders) on your back up hard drive. That way, you'll have an archive of both your pictures and the data that goes with them. (Note that DNGs and JPEGs store the metadata inside the file container, so there is no external XMP file to be concerned with.)

While you're covering your bases, you might also want to archive the custom workspaces and Collections you created in Bridge. Mac users can do so by backing up the Bridge CS4 folder located inside their User Library (Users→[user name]→ Library→Application Support→Adobe→Bridge CS4). Windows users can find these directories by going to C:\Users\[user name]\AppData\Roaming\Adobe\ Bridge CS4\Workspaces for the workspaces and C:\Users\[user name]\AppData\ Roaming\Adobe\Bridge CS4\Collections for the collections. (Note this presumes that C: is your system drive as it will be for most people.)

Your time is valuable. Preserve both your images and your work by backing up your metadata.

Where to Go from Here

First, give yourself a pat on the back. Doesn't it feel great to be organized? It's like walking into a clean room at home.

The next step is to use Adobe Camera Raw to apply a few basic image edits to your best pictures. Don't let the word *basic* fool you. This is sophisticated stuff that happens to be so easy to learn. Find out more in the next chapter.

Basic Image Editing in Camera Raw

INITIAL COLOR AND TONE ADJUSTMENTS

Many photographers have a hard time fighting the urge to jump directly into Photoshop once they find a photo or two they like. You may have that impulse now, after having identified your three- four-, and five-star images during the photo-editing process in Bridge. But stay with me here for a minute. Even though Photoshop is an amazing image editor, its place is later in the flow.

The bulk of your image editing will actually occur in another application known as Adobe Camera Raw. ACR is a plug-in that comes bundled with Photoshop CS4 and is hosted by either Photoshop or Bridge. To be perfectly candid, this is amazing software that has changed my approach to image processing. ACR lets you quickly fine-tune your photos using tools that are easy to recognize. For example, adjustments such as Exposure, Fill Light, Brightness, and Saturation are the sort of controls that you'll be working with. Even though the names of these controls sound familiar to you, that doesn't mean you get to skip this chapter. I'll show you how the Exposure slider lets you control the highlights, how you can use Brightness to control midtones, how you can recover shadow detail using Fill Light, and how Saturation affects color intensity. But you can see already that this conversation makes sense and the controls will be easy to remember.

To better understand the relationship between Photoshop and ACR, think about how you might paint a house. You'd use a sprayer or rollers for the larger surfaces, such as the walls. Then, you'd switch to a brush for the detail work and the finishing touches.

If you were to paint this wall, ACR would be your large-surface sprayer. Save Photoshop for the detail work.

Consider ACR as your large-surface sprayer and Photoshop as your detail brush. As Photoshop expert Katrin Eismann once remarked, "Adobe Camera Raw can make a lot of your pictures look great; Photoshop can make your best look perfect."

On the next few pages, I'll show you how to use some of the basic tools in ACR to quickly improve your three- and four-star images. For most pictures, these adjustments are all you'll ever need. In the next chapter, I'll show you a few of the advanced tools in ACR that you may want to use for specific images. But for now I want you to walk with me through the basic adjustments that you can apply to nearly any photograph.

COOL TOOLS

DESPITE ITS NAME, ACR IS NOT JUST FOR RAW FILES

It's true that ACR was originally designed to process raw files. But when the CS3 version hit the streets, Adobe added the capability to process JPEGs and TIFFs. At the same time, they incorporated a number of robust processing tools to enhance ACR's editing capabilities. With ACR, we now have a very powerful image processor that lives between Bridge and Photoshop in the image processing workflow. Besides its ease of use, one of the great benefits of using ACR is that it's nondestructive, even for JPEG files. That means your original files are left untouched, and your edits are stored as a separate set of instructions. Let me say that again in case you glossed over it: your original files are protected when you're working in ACR. Unlike Photoshop, if you click the Done button in ACR your original file is still protected, even though the picture you see has changes. At any time you can return the picture to its original state just by clicking a Reset button. This nondestructive feature takes on an additional dimension with JPEGs. Most photographers know that JPEG is a lossy format. But many are not always clear on how this works. Loss of information happens only when you recompress a JPEG file. You can open a JPEG as many times as you want, and then close it, and you will not lose picture detail. Only when you apply an image edit to the file do you force the file to recompress, and that's when you lose picture quality.

In ACR, the application reads the JPEG file but it doesn't recompress it. Instead, it stores the instructions as separate data. That's why ACR is nondestructive for JPEGs as well as raw files and TIFFs.

Combine this feature with the knowledge that your image edits are always reversible, and you can see why so many photographers have switched to ACR for the bulk of their work.

The Benefits of ACR

It's worth understanding a few important advantages of ACR , if for no other reason than to motivate you to use this application more often.

First, ACR is a nondestructive environment. When you open an image in this application, it saves all our edits as metadata rather than editsto the image itself, so your master is always protected. In addition, those metadata instructions take up very little hard disk space, far less than saving an entire copy of the picture or multiple adjustment layers in Photoshop. So, ACR is as efficient as it is smart.

And finally, the software's editing tools are highly advanced. So when you're working in ACR, you're using the latest generation of image editing controls.

By now, ACR is probably starting to sound pretty good to you. But it gets better. For example, when you access ACR through Bridge, none of your Photoshop resources are tapped. In other words, you can set up a batch-process job in Photoshop, let it run in the background, and work on another batch of images using the Bridge and ACR workflow—all at the same time!

ACR also provides some nice batch processing tools. So, if you have a handful of images that require the same global adjustment, such as white balance, you can quickly correct them in ACR. I'll show you some of those advanced techniques in the next chapter, after we master the basic workflow in this one.

Working on Images in ACR from Bridge

Now that you know a little more about ACR, let's put it to work. Keep in mind that while you make these adjustments, Photoshop remains idle. In all honesty, you don't need it yet. Right now, you're going to use the Bridge/ACR combination to improve the appearance of your images.

While you're working in Bridge, you can open an image in ACR in a few different ways. A simple method is to right-click (or Control-click if you're still on a one-button Mac mouse) a thumbnail and choose Open in Camera Raw from the contextual menu.

Another approach is to click a thumbnail and press ⌘-R (Ctrl-R). There's also an ACR icon in the upper-left corner of the Bridge toolbar. It's a little round icon that looks like a lens aperture. When you click it, you'll open any selected image in ACR. Finally, you can set a preference in Bridge that lets you simply double-click a picture to open it in ACR. Just go to Bridge Preferences, click General, and turn on the Double-Click Edits Camera Raw Settings in Bridge checkbox. Your image will open in the ACR interface, and you're ready to get to work.

Your image opens in the ACR interface

Setting Your Workflow Options

At the bottom of the ACR interface you'll notice a line of text between the Save Image and Open Image buttons. These are your workflow options. Click on the text to reveal a dialog box.

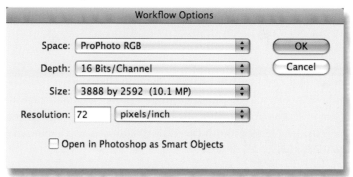

ACR workflow options set to maximum color space size (ProPhoto RGB) and bit depth (16). You may want to swtich your bit depth to 8 for smaller files.

You have five basic options in this dialog box:

Color space You have four different color spaces to choose from. And between you and me, there are 10 times that number of theories as to which one you should choose. Generally speaking, if you're editing for print output, choose Adobe RGB. If your destination is the Web, choose sRGB. And if you want to retain the maximum amount of color information while you decide what you're going to do with the image, select ProPhoto RGB. You can always change your mind later.

Bit depth For bit depth, you have the option of 8 or 16 bits per channel. If you're working with JPEGs, your files already have an 8-bit depth. So, you might as well keep it there. If you're working with raw files, though, you may want to consider choosing 16 bits for your initial editing because this lets you retain the maximum amount of information through the early stages of the process. But be warned: 16-bit files are about twice as large as 8-bit files. So, for noncritical use, you may want to choose 8 bits per channel, even for your raw files.

Size As for size, I recommend that you stick with your camera's native resolution. So if you have a 10-megapixel camera, leave the 10-megapixel option selected in the Size pop-up menu. The native resolution should already be selected for you.

Resolution The resolution setting isn't that important at this stage of the workflow. Resolution doesn't matter until you output your file. So you can have the resolution set at 240 or 72—either is fine. Resolution does matter when you get ready to make a print. But you won't be doing that in ACR.

Smart Objects You have the option of using Smart Objects when opening your files in Photoshop. When you select this option the Open button at the bottom of the ACR interface changes to Open Object. Smart Objects have the benefit of letting you use ACR adjustments even after you've opened the object in Photoshop. But when you take this route you're creating larger file sizes. I'll talk more about Smart Objects in the next chapter. For now, leave this box unchecked.

Your workflow options are now in order, and ACR will retain them. However, keep in mind that you can change them whenever you want by simply clicking the text link again. Once you're done setting these options, don't forget to click OK.

A Quick Tour of the Bottom Buttons

Earlier, I mentioned a few of the buttons at the bottom of the ACR interface. Each has a specific function:

Save Image This button should really be Save As, in my opinion. Once you've finished editing an image in ACR, click the Save Image button if you want to save a copy of it in another format. Your basic options are JPEG, TIFF, Photoshop, and Digital Negative. You can also click this button to choose the location for your saved file. This is very handy when you're working with a raw file and you want to save a JPEG copy of it to send to a friend.

If you hold down the Option key (Alt for Windows), Save Image simply becomes Save. In this case, ACR will bypass the dialog box and save your image to the location and in the format of your previous settings. This can be a timesaver when you're saving a number of images using the same settings.

The three buttons on the bottom-right side of the ACR interface

Open Image The Open Image button opens your ACR file in Photoshop so that you can continue to perfect it using the specialized tools in Photoshop.

Cancel (and Reset) The Cancel button is self-explanatory. However, when you simultaneously hold down the Option key (Alt on Windows) and the Cancel button, the Cancel button turns into a Reset button. This is handy when you're playing with image adjustments in ACR, and you decide you don't like the changes you've made. The Reset button lets you "reset" your entire set of edits, returning the picture to its original state.

Done The Done button saves your changes as data and associates the data with the original file. After you click Done, you should see your thumbnail updated in Bridge. This operation demonstrates the nondestructive nature of ACR. Even though your image now reflects the changes you've made, you can go back and make more adjustments, or remove them altogether, without compromising the picture itself.

Your First Image Edit

Now it's time to open an image and make it pretty. You'll work with some of the items on the toolbar at the top of the ACR interface, especially the White Balance eyedropper and the Crop tool. We'll also spend some time with many of the Control tabs on the right side of your picture. ACR has eight tabs, each with its own set of adjustments. For this workflow, you'll concentrate on the Basic, Tone Curve, HSL/Grayscale, and Detail tabs, in that order. Your image will improve as you move from tab to tab. Some of your pictures will require only a few minor adjustments in the Basic tab, whereas others will require a bit more finesse. That choice is yours.

Start by Cropping

Since cropping in ACR is a nondestructive process, this is a great place to start your image editing workflow. The act of refining your composition forces you to examine your picture to determine which elements are necessary and which ones can go away. If you change your mind later, fear not; just select the Crop tool again and you'll see the photo in its entirety, so you can compose it differently. (Ah, the joys of nondestructive editing!)

Select the Crop tool from the toolbar in the upper-left corner, and then drag the mouse to select the area you want to keep.

Click the Crop tool and drag your mouse across the area you want to keep. You can use the handles to adjust the framing. Or, if you want, hold the mouse pointer down on the Crop tool and choose one of the preset aspect ratios from the menu that pops up. Once you've framed the image to your liking, press the Return key to apply the crop. As you work on the image, you may change your mind about the composition. Just click the Crop tool again and readjust.

First Edits in the Basic Tab

It's time now to move to the Control tabs for tone and color adjustments. The Basic tab is our first stop. Many photographers can correct the bulk of their pictures right here and call it a day. These tone and color adjustments are easy to use and give you great control over the appearance of your images.

Tone adjustments in the exposure slider

You'll start with the Exposure slider. Even though there's an Auto link above it, I tend to avoid that link because I think it overexposes many of my pictures. You can try it if you want, and then click Default to return to your original exposure.

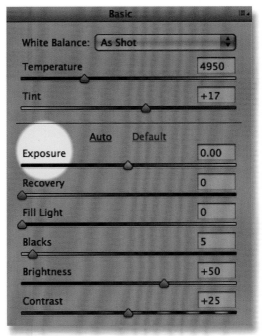

The Exposure slider in the Basic tab

Instead, let's take control of our tone adjustments. Start with the Exposure slider, which sets the highlight point. Hold down the Option/Alt key and drag the Exposure slider to the right and left. This activates the clipping overlay to show you what areas are overexposed. All black means no clipping, and white indicates clipping in all channels. Red, green, and blue tell you that there is clipping in only those individual channels. My approach is to move the Exposure slider back and forth until I've eliminated clipping, except for spectral highlights that will be blown out no matter what. (A bright bulb is a bright bulb, and you're not going to get detail in those areas.)

Setting	Result
Exposure	Controls basic highlights
Recovery	"Recovers" highlight detail
Fill Light	"Recovers" shadow detail
Blacks	Controls shadow areas
Brightness	Controls basic midtones
Contrast	Applies basic "S" contrast curve

Now jump down to the Brightness slider to adjust the midtones. This is a subjective correction, so have fun and make those midtones look good to your eyes. If your image is looking a little too bright in the dark areas, don't worry. Move the Blacks slider until you have the look you want. Double-check your adjustment by holding down the Option/Alt key to reveal clipping in the shadow areas. A little plugging in the darkest blacks is fine, but if you're showing a lot of shadow detail loss, you might want to back off a bit.

Once you've made your basic highlight, midtone, and shadow adjustments, you might want to play with the Contrast slider. This is similar to creating an S-curve in the Curves control. Contrast lightens the brighter areas and pulls down the darker areas without compromising (too much) the tones at the ends of the histogram. This is a visual adjustment based on personal taste.

Some images suffer from large areas of detail loss in the shadows. You can recover some of that information using the Fill Light slider. This isn't a cure for a terribly exposed image, but it does come in handy when you want to reveal just a bit more detail in the dark areas. Its counterpart for highlights is the Recovery slider. Again, this is a fine-tuning adjustment that you can use after setting the Exposure, Brightness, and Blacks sliders. But Recovery can work wonders on subtle bright areas, such as blown-out highlights in a white shirt or on a white wall.

Before moving on, review your exposure corrections. Start by clicking on the "shadow clipping warning" indicator in the upper-left corner of the histogram. Note the dark areas that are plugged up and decide whether further work is needed, then click the triangle again to turn off the warning. Next, click the "highlight clipping warning" triangle in the upper-right corner of the histogram and take a look at the bright areas where you've lost detail. Does the image look OK? Great! Click again to turn off the warning.

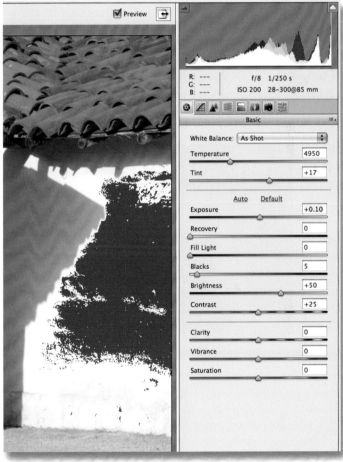

The area highlighted in red indicates highlight clipping. The image has no detail in that area. You can restore detail by moving the Exposure slider to the left, or the Recovery slider to the right.

I've saved the best check for last. Turn on the Preview checkbox to see the version of your picture prior to the Exposure adjustments (you also can toggle this off and on via the "P" key). I bet this brings a smile to your face because your current version (check the Preview box to see) probably looks miles better than what you started with. You're now ready to color-correct.

Color adjustments

Once you have your tones under control, it's easier to make global color adjustments. Raw shooters will have the full complement of white balance presets available to them in the White Balance pop-up menu. (For JPEG images, ACR will list only As Shot, Auto, and Custom.) You can take a peek at different presets by choosing Daylight, Cloudy, Shade, and so on. If you find a preset you like, stop there. If none of the presets are quite right, try the White Balance tool—it's the eyedropper icon that's third from the left on the toolbar at the top of the ACR interface.

Use the White Balance tool to automatically color-balance your images.

Choose the White Balance tool and click an area of the photograph that should be neutral, such as a white wall, cloud, or something similar. The tool will make that tone neutral, and the other colors in the image will fall into line. If the adjustment isn't quite what you expected, click a different neutral area to get a different result.

You can then fine-tune your adjustment (if necessary) by moving the Temperature and Tint sliders. Temperature is a blue/yellow modifier, and Tint affects all colors shifting between more green and more magenta. Keep an eye on your neutral areas when fine-tuning with these sliders. If they become too warm or too cool, you may want to reset using the White Balance tool.

Fine-Tuning Your Image

Your picture is probably looking pretty good at this point, but ACR has many more tricks up its sleeve for fine-tuning your adjustments.

Fine-Tuning in the Basic Tab

We still have a few more tools in the Basic tab to cover. If you'd like to add a little midtone contrast to your image, try moving the Clarity slider to the right. This provides a little "snap" to your image, but it doesn't affect the very bright or dark areas.

Vibrance is another intelligent control that boosts color in areas of lower saturation. What's nice about this control is that it does a decent job of protecting skin tones while adding saturation to other elements in the composition.

And if you want to increase or decrease the saturation of all the colors in the image, use the Saturation slider.

Setting	Result
Clarity	Provides a midtone contrast boost with mild sharpening
Vibrance	Boosts low-saturated colors; protects skin tones
Saturation	Applies an across-the-board saturation boost

Fine-Tuning Tonal Adjustments in the Tone Curve Tab

Some images may require more precise tonal adjustments that go beyond the work you did in the Basic tab. Fortunately, the Tone Curve tab is designed for that. You can use the traditional "point curve" approach, but I prefer the newer parametric controls that let you adjust your curve using four properties sliders: Highlights, Lights, Darks, and Shadows. Let's start there.

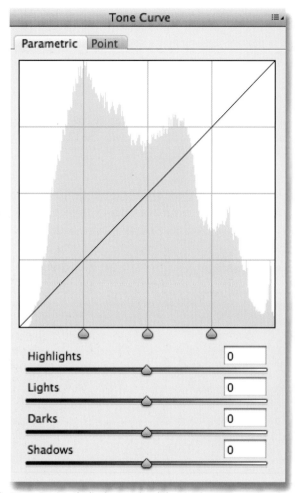

The Tone Curve tab displaying the sliders in the Parametric sub-tab

The first thing that jumps out at you in the Tone Curve tab is the big graphical area that shows the histogram for your image in gray with a grid superimposed over it. This histogram is for reference, representing all the tones in your image— darks on the left, spanning to lights on the right—and it doesn't change shape as you make your adjustments. (The histogram at the top of the interface is active and will show you your changes.) A diagonal line goes from one corner of the Tone Curve histogram to the other. As you move the four sliders at the bottom, the diagonal line changes shape to represent your tonal adjustments. The lower end of the diagonal represents dark tones and the upper end is for light tones.

CHECKING YOUR WORK AGAIN

You've already used the Preview toggle to see a set of adjustments turned off and on. But the Preview toggle works only for the changes you made during this ACR session. If you want to see the original version of your picture and compare that to what you're looking at now, go to the Settings menu (located to the right of the Basic label) and choose Camera Raw Defaults. Then select Custom Settings to reapply the work you've done to this point.

This menu also gives you some versioning control. Let's say you're happy with your image for now, so you click Done in the bottom-right corner of the interface. Then later, you decide to open the image again in ACR and play some more. Maybe this time you want to convert the image to grayscale.

Setting	Result
Camera Raw Defaults	Shows your picture in its original state with default processing
Custom Settings	Renders your picture with your current adjustments applied
Image Settings	Shows a previous set of "saved" edits

Choose Camera Raw and you'll go back to the original version, before any adjustments. Choose Image Settings to bring the picture back to the place it was when you had clicked on "Done." And finally, if you go to "Custom," the picture jumps to the current set of adjustments, which in this case is Grayscale.

At the base of the grid are three "region markers" that let you determine the sizes of the areas affected by your changes. For the time being, you don't have to worry

about this. The current positions of the region markers will serve you just fine as you get comfortable working with curves. By default, they divide the histogram equally into four tonal sections (from left to right): shadows, darks, lights, and highlights, as indicated by the vertical grid lines. However, you can resize those equal proportions by moving a region marker to the left or right. So, for example, if you want your highlights adjustment to affect a larger area, move the highlight region marker (the one on the right) to the left. Now, when you move the High-lights properties slider, it will affect a greater area of your image. As I said, this isn't something you would need to play with at first. But keep it in your back pocket for the future.

What you do want to focus on are the four properties sliders that let you perfect your image's tonal adjustments. As you move the Highlights triangle to the right, you'll see changes to the brightest areas of your photograph. You'll also see the shape of the diagonal line bow outward at the top. If you move the Shadows slider to the left, you'll see the shadow areas of the image get darker and the diagonal line bow out in the opposite direction. You've now made a classic "S" curve adjustment, which increases the contrast of your image.

The nice thing about curves, unlike the Contrast adjustment in the Basic tab, is that you can play with just the shadows or just the highlights instead of having to change them in tandem. The Tone Curve controls are also very precise and provide graphical feedback as you manipulate them. And if you create settings that you want to keep and apply to other images, just choose Save Settings from the Settings pop-up menu and give your custom adjustment a descriptive label. That custom adjustment will then appear in the Settings pop-up menu for use in the future.

Even though there is no "right way" to use the Tone Curve tool, you do want to keep a few things in mind. Generally, these are subtle adjustments with gentle curve patterns. You should avoid "cliffs" and "plateaus" in your curve, because such patterns result in unnatural tone distribution and your picture won't look right. I also tend to stay away from adjustments that move the line parallel to the top and bottom of the graph, because that means I have clipping in the highlights and shadows.

If you're more comfortable adjusting your curve using points, click the Point tab, choose a starting profile from the Curve pop-up menu, and drag the points on the curve to fine-tune your adjustment.

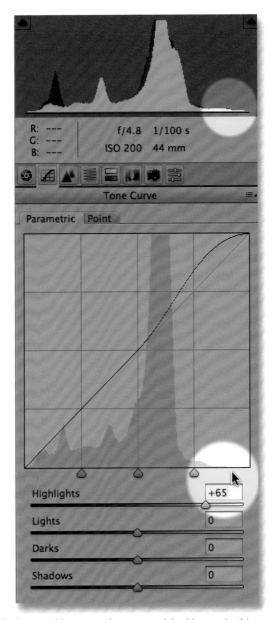

The bottom histogram shows my original image. In this case,
it's lacking information in the highlight area as indicated by the
pointer. So I moved the Highlights slider to +65. The top histogram
shows my adjustment with information in the highlights.

If you want to work on a specific area of the image, put your mouse pointer on that tonal area, hold down the ⌘ key (Ctrl on Windows), and click. A point for that area will be added to the curve graph, and you can now move the point to adjust that specific tone. I like to use the up and down arrows for this adjustment because that's easier than dragging the point marker. If you want to remove a point, click it once and press the Delete key.

I've found that it's easier to control curve adjustments with fewer points. I generally work with three or four points on a curve. Even though I prefer the parametric adjustments for the bulk of my work, I do use points when I want to target a specific tone.

> **REMINDER:** Checking Your Work Again
>
> Aside from looking at the picture itself, you can check your work by turning on the shadow and highlight clipping warnings. Click the triangles at the top of the active histogram, or press the "O" key for highlights and the "U" key for shadows. As with the tonal work you did in the Basic tab, you want to avoid excessive clipping in these areas.

Fine-Tuning Color in the HSL/Grayscale Tab

Just as the adjustments in the Tone Curve tab let you fine-tune your lights and darks, the sliders in the HSL/Grayscale tab let you work on specific colors. You have eight color types to work with: reds, oranges, yellows, greens, aquas, blues, purples, and magentas. The first three color types are those we usually find in skin tones.

Once you start working with a color type—reds, for example—you can tweak its hue, saturation, and luminance. That's where the HSL part of the tab gets its name:

Hue Lets you adjust the character of a color. Do you want your yellow to be more orangish or greenish?

Saturation Lets you adjust the intensity of the color.

Luminance Determines how bright or dark the color will be.

At first, you may wonder, "Well, how am I going to use this?" I'll give you a practical example. Let's say you have a landscape shot with a blue sky, clouds, and some foliage in the foreground. The sky looks nice, but you want a little more drama.

The HSL/Grayscale tab

Start with the Hue tab to adjust the Blues slider so that the sky is the exact color you want (sometimes the Cyan is a better choice; experiment as needed). Then go to the Saturation tab and increase the intensity of the Blue. Finally, hop over to the Luminance tab to darken the sky a bit, thereby making the clouds jump out more. The effect you've just created in the HSL tab is very similar to what you could've achieved with a polarizing filter, if you happened to have one with you that day. Had you forgotten it, then you have ACR to help you reenact a similar effect.

Another popular use of HSL is to fine-tune skin tones. By working with the Reds, Oranges, and Yellows sliders, you can correct or even improve the appearance of your subjects. One thing to keep in mind, however, is that if those colors appear in other areas of the image, those areas will also be affected. So, if your subject is wearing a yellow shirt while you're adjusting her skin tones, the color of her shirt will change too.

Finishing Touches in the Detail Tab

By now your image should be looking pretty good. By adding a few finishing touches to it via the Detail tab, you can restore some of the "pop" that was lost in the digital capture process. Two control areas are available to you in this tab: Sharpening and Noise Reduction. Most of the time you'll be using Sharpening, but I'll say a few words about Noise Reduction too.

Input Sharpening

Let's start with sharpening your picture. At this stage of the game we refer to this process as "input sharpening." The goal is to restore some of the detail that was lost in the process of capturing the image. Later on, in Photoshop, you'll probably do some output sharpening too. But we'll use different tools for that endeavor.

Input sharpening in the Detail tab

To get started in ACR, click the Detail tab (the third tab from the left) and note the four control sliders: Amount, Radius, Detail, and Masking. Here's the basic description of each:

Amount Controls how strong the effect is

Radius Refers to how many pixels out from the edge are affected by the sharpening

Detail Helps to control the halo effect you sometimes see in sharpened images

Masking Lets you create an edge mask controlling what gets sharpened and what doesn't

At first, the procedure might seem unintuitive, but once you've gone through the process, you'll really appreciate these tools.

Start by setting your image to 100 percent in the Zoom Level pop-up menu in the lower-left corner of the interface. Hold down the spacebar to switch to the Hand tool so that you can position the important part of the image in the frame. With people and animals, this will usually be the eyes, with some background. Then hold down the Option/Alt key and move the Masking slider to the right until you see just the details you want to sharpen. The sharpening filters will not affect the black areas of the mask.

Next, move Amount to 100. The effect will be very heavy-handed at this point, but you'll back it off once you set the other sliders. This is just a temporary adjustment. Then play with the Radius slider until you get a rendering that looks good. Generally speaking, the radius will be set between .8 and 1.6. Also experiment with the Detail slider, keeping a wary eye out for halos appearing at the higher settings. I usually keep the Detail setting low, between 15 and 25. Finally, go back to the Amount slider and back it off until you find that perfect compromise between good image detail and that over-sharpened look.

Setting	Result
Amount	Controls how strong the effect is
Radius	Determines how many pixels out from the edge are affected by the sharpening
Detail	Helps to control the halo effect
Masking	Creates an edge mask controlling what gets sharpened and what doesn't

You can check your work by toggling the Preview (P) key off and on. You should see quite a difference between the corrected and original versions.

Noise Reduction

Noise has always been with us. In the film days, we called it "grain." And it did look like a sandy overlay on our images. In digital photography, noise has replaced grain as those artifacts that appear, most often, at very high ISO settings. Since we often prefer to have smooth, continuous tones in our pictures, noise is considered undesirable. Fortunately, ACR has some tools to help control noise.

The Detail tab supports two types of noise reduction: Luminance and Color. I recommend using Color as your first option because it attempts to remove the annoying color artifacts that we call *noise* with less impact on image sharpness than Luminance reduction. So, for detailed images, I usually keep my hands off the Luminance slider and work with the Color slider.

However, if your main concern is to reduce noise in blue skies, bodies of water, and other areas where detail isn't as important, Luminance can be a powerful noise reduction tool.

Noise reduction sliders in the Detail tab

In all honesty, these noise reduction filters aren't as effective as most third-party plug-ins for Photoshop that specialize in this sort of thing. But they can improve certain types of images. Just keep an eye on detail to make sure you're not compromising too much sharpness for a little noise reduction.

And These Were Just the Basic Tools

You've tapped a number of powerful adjustments in this first foray into Adobe Camera Raw. These steps will serve you well for the majority of your images. In the next chapter, I'll show you some advanced techniques that will improve both quality and efficiency.

Advanced Camera Raw Techniques

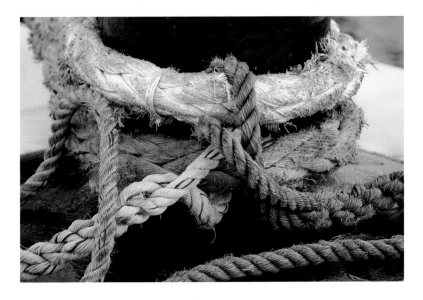

The basic workflow you learned in Chapter 4 will let you process images quickly and skillfully. And I think it's good to practice with those steps until they become second nature. Once you've mastered that process, however, there are more techniques that will broaden your capabilities. In this chapter, I'll show you a handful of advanced techniques that'll serve you well with certain images. These tools aren't for every shot you take, but they'll help you make certain good shots look absolutely great.

Batch Processing in ACR

When you shoot a series of images under similar conditions, you can use batch processing to adjust multiple pictures simultaneously. This saves a tremendous amount of time. And the process is easy.

Begin in Bridge by selecting the pictures you want to process by ⌘-clicking them (Ctrl-clicking in Windows). Then open them in ACR using ⌘-R (Ctrl-R). Your pictures will appear in a column down the left side of the interface. Click the top thumbnail to select it, and then adjust the image. Keep in mind which controls you used.

Now click Select All, and then click Synchronize—both buttons reside at the top of the thumbnail column. ACR will present you with a Synchronize dialog box.

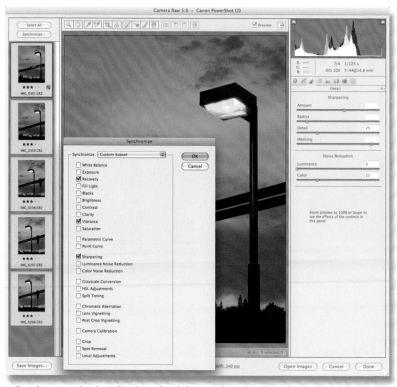

Batch processing in ACR. I've edited the top thumbnail, and I'm about to apply those edits to the other images.

Choose the settings you want to synchronize by turning on their respective checkboxes. (If you forget which adjustments you made to the primary image, you can select Everything from the Synchronize pop-up menu. Just keep in mind that this means *everything*.) ACR applies the corrections that you made to the first image to all the other selected pictures . You can review your work by toggling the P key to turn the preview off and on.

If you think these are corrections you'll use in the future, then click on the Settings Menu icon to reveal the pop-up menu and choose Save Settings. Turn on the checkboxes that represent the adjustments you want to save, click Save, give your preset a name, and click Save again.

Click the Settings Menu icon to reveal the Save Settings command

You can use this preset in ACR by selecting it from the settings menu and choosing Apply Preset. Or, an even more convenient way to go is to apply the preset in Bridge without ever having to open your picture in ACR. Just right-click on a thumbnail and choose Develop Settings. Your presets will appear in that list. Click the one you want to apply, and presto, the thumbnail will instantly reflect the change. It doesn't get any more convenient than that.

If you decide you don't like the way the adjustment looks, right-click the adjust-ment icon in the upper-right corner of the thumbnail and choose Camera Raw Defaults from the Develop Settings submenu. Your image will be returned to its original state. You can also use Clear Settings to remove the preset.

Black-and-White Conversion in ACR

ACR offers tremendous controls for black-and-white conversion, and I'm going to show you a few of my favorites. Since all the work you do in this application is nondestructive, you could convert your original image to black and white know-ing that you can always return to its original state by selecting Camera Raw De-faults from the Settings menu. These techniques work for raw, JPEG, and TIFF files. I prefer starting with a raw file for black-and-white conversion because of the rich tonality that raw files contain.

As part of this process, I also want to show you another technique for file man-agement in Bridge. This works hand in hand with the image editing you'll do in ACR. While in Bridge, instead of converting the original image, make a copy of it. Select the picture and then choose Edit→Duplicate to create a digital copy of your original file. Now select both images—the original and the duplicate—and choose Stacks→Group as Stack. You've now placed both your original and your soon-to-be-grayscale pictures in a Stack. Click on the title of the duplicated im-age so that it highlights, and then change the word *copy* to *B&W*.

*Group your original and duplicate versions together as a Stack.
Then you can convert the duplicate to black and white.*

The advantage to this approach is that you'll have both a color version and a black-and-white version of your picture side by side in Bridge. You can decide which is best depending on the situation. The downside is that you've created a high-resolution copy of the file. So if your original color image was 12 MB, the copy is too. However, keep in mind that the Bridge/ACR workflow is not layer-based, as it is in Photoshop. So your 12-megabyte file will remain that size unless you open it in Photoshop and add layers, where it can swell to many times its original size. In other words, making a copy of the file in Bridge is often more efficient than using Save As in Photoshop.

Now open the image in ACR, and you're ready to get to work. I suggest that you begin by making any tonal adjustments you'd normally make in the Basic tab. Examine the shot and its histogram, and then use the Exposure, Brightness, and Blacks sliders until you're generally satisfied with the image's appearance.

The Convert to Grayscale Approach in the HSL Tab

You're ready to make your black-and-white conversion. Click the HSL/Grayscale tab and turn on the Convert to Grayscale checkbox. Two things will happen. First, your image will lose all its color. Second, the HSL-related tabs will go away and be replaced by the Grayscale Mix tab. The sliders in this tab adjust the luminance for each of the eight colors. That's right, *colors*. They're still there, even though you're looking at a black-and-white image. Press the letter-P key to reveal the original color image.

This is one of the reasons why conversion in ACR is so powerful. Let's say there's a tone in your B&W image that is too dark, and you want to lighten it. Press the letter-P key, note what color the area in question is, press the letter-P key again to return to grayscale, and then move the corresponding color slider to the right. Magically, that tone will lighten. Play with the appropriate sliders until you get the look you want. Then click Done.

You'll return to Bridge with your black-and-white conversion there next to its color original in the stack. If you want the black-and-white version on top of the stack so that it's the image that shows when you collapse the stack, and then click on Stacks→Promote to Top of Stack.

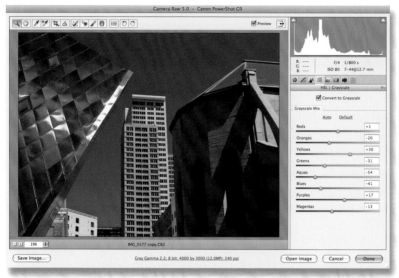

Enabling the Convert to Grayscale function in the HSL/Grayscale tab

Using the Convert to Grayscale approach gives you lots of control over the tonal adjustments of the black-and-white image. In addition to the eight color sliders, you can use all the sliders in the Basic tab (except for Vibrance and Saturation), the adjustments in the Tone Curve tab, Split Toning, and Sharpening and Noise Reduction in the Detail tab. If you were to save your image or open it in Photoshop, you'd see that it's listed as a grayscale photo in the Mode menu.

The Desaturate Approach in the HSL Tab

If you want to avoid converting your image to Grayscale mode, and instead leave it listed as an RGB file, you can use the desaturate method in the HSL tab. This approach lets you use the Vibrance and Saturation sliders for fine adjustments. Furthermore, some experts, such as Katrin Eismann, believe this approach produces less image noise. This time, instead of checking the Convert to Grayscale box, click on the Saturation tab and move all eight sliders to the far left. To make this easier next time, click the Settings Menu icon and choose Save Settings so that you can make this a preset and apply the conversion with just a single click.

Once you've desaturated the photo, click on the Luminance tab and play with the color channels as before. Another set of controls you might want to play with are the White Balance sliders in the Basic tab. You can get some great effects with Temperature and Tint. And all the luminance sliders work great too, such as Exposure and Brightness.

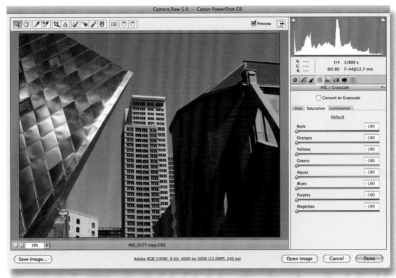

Using the desaturate method in the HSL tab of ACR

When the converted image looks the way you want, click Done to return to Bridge. If you were to open this image in Photoshop and go to the Mode pop-up menu (Image Mode), you'd see that it's an RGB file.

Q U E S T I O N : So, Which Is the Best Approach?

I've produced terrific prints from each of these approaches. But more and more I'm leaning toward the desaturate method for printing and the Convert to Grayscale approach for Web work. Desaturate produces bigger files and retains information in all three color channels. Grayscale images look great, especially on the Web, but the files are one-third the size because of the conversion to grayscale color space. In all honesty, it would be tough to tell the difference by looking at the prints independently. So I suggest that you play with both, and choose the method that best fits your particular situation.

Spot Removal in Adobe Camera Raw

I prefer removing sensor dust and other aggravating imperfections in ACR rather than in Photoshop. Not only is the Spot Removal tool in ACR easy to use, but also you can batch-correct multiple images. This is particularly helpful when you've noticed a speck of dust in the sky on the series of 30 landscape shots you captured earlier in the day.

Start in Bridge by selecting the images you want to fix. Then press ⌘-R (Ctrl-R) to open them in ACR. Your thumbnails will line up in a column down the left side of the interface, with the top one selected and displayed in the image preview area.

Increase the magnification of the preview by clicking the "+" button in the lower-left corner of the interface. You can move the image around by pressing the spacebar to change the cursor into the Hand tool. Once you have a good look at your imperfection, click the Spot Removal tool located in the middle of the ACR toolbar. The Image Settings panel on the right side will display a Radius slider and an Opacity slider. You'll also see a little pop-up menu that lets you choose Heal or Clone. Leave it on Heal.

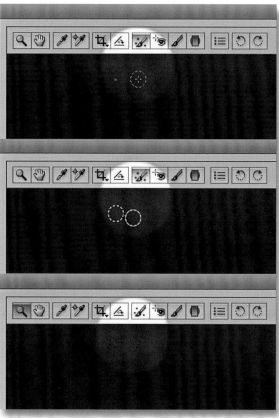

Spot removal steps in ACR

Move the Radius slider to the right until the diameter of the cursor is large enough to easily cover the spot, with a little room left over. You might find this awkward because you don't actually get to see the diameter while you're moving the slider. So instead, use the right and left bracket keys while the cursor is in the image area. You'll find this to be much more efficient. Center the cursor over the imperfection and click. ACR will "lock in" on your selected area (the red circle) and create another circle (green) that will serve as your source area. It usually does a pretty good job of preselecting the source location. But if you prefer somewhere else, just click in the red circle and drag it to the area you want. Click the mouse button, and ACR will remove the blemish.

For most corrections, you'll want the Opacity slider set all the way to 100. But you can back it off to let more of the original image show through. Watch the Image Preview Area as you move the slider. If you find the red and green circles distracting while reviewing your correction, you can hide them temporarily by unchecking the Show Overlay box.

You can apply this correction to all the images you've opened in ACR. Leaving the top thumbnail selected, scroll all the way down to the bottom image, hold down the Shift key, and click the thumbnail. Now all your pictures are selected. You can also click Select All.

Click the Synchronize button to reveal its dialog box, make sure Spot Removal is the only checkbox that's turned on in the Synchronize dialog box, and then click OK. ACR will apply the correction to all the images. Once the process has completed, click Done in ACR to return to Bridge.

Cloning with the Spot Removal Brush

If you're accustomed to the Clone Stamp tool in Photoshop, you might be disappointed when you try to clone an area in ACR with the Spot Removal brush. You have far less control here.

Basically, the Spot Removal brush functions the same way as when you're in Heal mode, except that you can't "paint" as you can in Photoshop. You pick an area to alter, drag the green circle to the area you want to use as the source, and that's it. It's more like a "lift and stamp" process than cloning as we know it. Plus, ACR adds feathering on its own, so you can't even get a clean reproduction.

> **REMINDER:** The Right Tool for the Job
>
> The Spot Removal tool in Heal mode is probably the easiest way to attack sensor dust, especially if you have to correct multiple images. I recommend using ACR. But you have more control over cloning in Photoshop. Save that work for later on.

Localized Corrections with the Adjustment Brush

The Adjustment brush in ACR lets you make localized corrections for exposure, brightness, contrast, saturation, clarity, and sharpness. The brush controls themselves are fairly advanced, enabling you to choose brush diameter and the feathering around it. You can even set the density for your correction giving you the opportunity to decide how much of the original image should show through your correction.

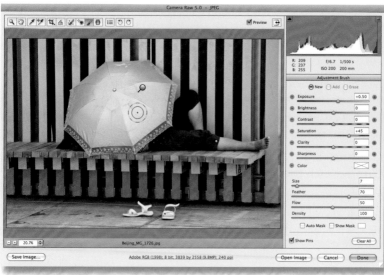

Making localized saturation corrections with the Adjustment brush. The pin indicates the area you're working on. The solid circle is the actual adjustment area. The space between the solid circle and the dashed circle is the feathering zone.

The first step toward a happy Adjustment brush experience is to learn how to work with the brush. You can use the Size and Feather sliders as a starting point. But once you get knee-deep into the correction, you're going to want to use keyboard commands to change these parameters.

To begin, select the Adjustment brush, and place your mouse pointer over the area you want to work on. Tap the right and left bracket keys to enlarge or reduce the diameter of your brush. As the diameter increases, you'll see two circles. The solid-line circle is the size of the brush, and the dashed-line circle is the area of feathering outside the correction. Feathering is important because it creates a tapering-off zone between the correction and the rest of the image. This lets your corrections blend better with the overall picture.

You can adjust the feathering zone by holding down the Shift key and tapping the left and right bracket keys. Your intuition might tell you that these controls would change the diameter of the dashed line, but they actually change the solid-line brush diameter relative to the feathering zone. After just a few minutes of playing with these commands, you'll get the knack of it.

A fun way to get comfortable with this tool is to selectively increase the saturation of an object in the image. Set your brush size and feathering area with Flow set to 50 and Density set to 100. Move the Saturation slider to +50 and start painting on the object. Right away you'll see a difference. Paint the entire object, and then toggle the P key to turn the preview off and on. After you've painted an area, you can change the intensity of the adjustment by moving the slider. Increase the saturation to 75 or 100 and you'll see the changes reflected in the picture.

Chances are you overlapped into areas you didn't want to adjust. You can easily clean those up. Turn on the Show Mask checkbox to see an overlay representing your correction. Click the Erase radio button (located above the sliders), reduce your brush diameter and tidy up the areas where the mask spills outside the edges and over the area you want to adjust. At this point you'll probably be uttering "cool" or something similar under your breath. Can you believe you have the power to make this type of nondestructive edit? You're not even in Photoshop yet!

I did say "nondestructive," didn't I? Let's test my assertion. Click Done to return to Bridge. You'll see a little adjustment badge in the upper-right corner of the thumbnail of the image you just painted. That means you've made edits to the picture in ACR.

Choose the picture by clicking once on it and then reopen it in ACR by pressing ⌘-R (Ctrl-R). Click the Adjustment Brush icon in the Toolbar. Now turn on the Show Pins checkbox. You'll see what looks like a thumbtack appear where you made your saturation adjustment. Make sure Show Mask is checked, and then click the pin. The adjustment mask will appear again, and you can make further changes to your image.

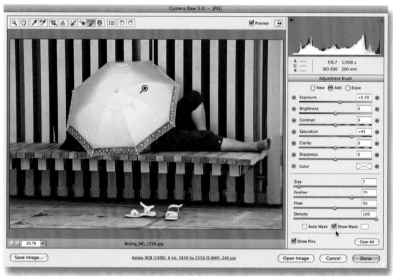

When you turn on the Show Mask checkbox (see the arrow pointer), ACR displays a mask that indicates the areas you've worked on.

In fact, because these edits are nondestructive, you can change your mind as many times as you want with absolutely no penalty. If you decide you want to get rid of the adjustment altogether, just make sure the pin is selected and then press the Delete key. Oops! You didn't really want to do that. Press ⌘-Z (Ctrl-Z) to reinstate the adjustment.

You can create multiple adjustment pins. Click the New radio button and start a new correction. If you want to alter a particular correction, even if it's in another part of the image, make sure the correct pin is selected and then click the Add radio button. The changes you make will be associated with the pin that's selected. I do recommend, however, that you keep your type of adjustments the same

for each pin. It will keep things simple and prevent confusion. You can clear all of your pins at once by clicking the Clear All button in the lower right-hand corner.

Here are some handy keyboard shortcuts that you might want to note. If you're adding to a pin and decide you want to create a new one, just tap the letter-N key. You can use the Tab key to move downward from slider control to slider control, or Shift-Tab to move upward. You can toggle the Mask overlay on and off with the letter-Y key, and the letter-V key does the same thing for the pins.

ACR also features a couple of semiautomatic controls that I want to show you. For instance, the sliders have presets. If you click the "–" button to the left of a slider, it will decrease the slider's effect in regular increments. The "+" button does just the opposite.

The Auto Mask function employs some edge detection to help you "stay within the lines." It's not foolproof by any means, but if you keep the outer edge of your Adjustment brush close to the outer edge of the object you're painting, Auto Mask will do a reasonable job of containing your adjustment. I like to use it with Show Mask turned on so that I can see precisely the affected areas. Using Auto Mask can save you cleanup time.

> **QUESTION:** Adjustment Brush Instead of Localized Corrections in Photoshop?
>
> Once you've experienced the ease and power of the Adjustment brush, you may feel guilty for making localized corrections here instead of in Photoshop. My recommendation is to deal with the guilt and keep using this tool. And thanks to the Auto Mask and Erase functions, you should be able to make the bulk of your localized corrections here, saving Photoshop for the really complicated stuff.

Tonal and Color Adjustments with the Graduated Filter Tool

Another new (and terrific) addition to the latest version of ACR is the Graduated Filter tool. It lets you nondestructively apply graduated tonal and color corrections to your image using a simple graduated overlay that you drag in any direction, and seven slider controls to modify the selected area.

Before-and-after images using the Graduated Filter tool in ACR. The three dashed lines indicate modified areas. I made other corrections to the bottom image.

This new addition is analogous to the expensive graduated filters photographers placed over their lenses to balance a bright sky with a darker landscape. The thinking was that by placing a filter that was dark on one side and gradually got lighter toward the other side, you could compress the dynamic range enough to let your camera capture both a bright sky and a dark foreground with one exposure.

These filters were made popular by outdoor photographers such as Galen Rowell who produced amazing scenics that tamed the entire tonal range, resulting in vibrant skies and foregrounds. The problem with graduated filters was that they were expensive, and you had to buy a separate filter for every type of correction. So you'd end up with a couple of neutral density filters, and a handful of color-correction versions to tote around. You could use these filters on your digital SLR. But why? Now you can record the picture in raw, and then make a more precise correction with the Graduated Filter tool in ACR. Plus, since it's a nondestructive tool, you can revisit the image at any time and make a different correction without having to save a new version.

Types of Graduated Corrections Available

You can make three types of corrections with this tool. The first three sliders are tonal: Exposure, Brightness, and Contrast. There are two sliders dedicated to detail: Clarity and Sharpness. And finally, you have two sliders dedicated to color: Saturation and Color. Each slider has presets that you can access by clicking the "+" or "−" button. The presets are contextual. For example, the presets for the Exposure slider make the affected area lighter or darker, whereas the presets for the Color slider make the image warmer or cooler (more yellow or more blue).

Maybe the best way to give you a feel for how these sliders work is to walk you through the adjustment of an image.

Adjusting a Sample Image with the Graduated Filter Tool

I start by opening an image in Adobe Camera Raw. But before I actually use the tool, I take a minute to analyze the photo. What do I actually want to do here? I have a shot of a rusty door hinge with white bricks on the right side and weathered wood on the left. I'd like to tone down the bright bricks while retaining the richness of the wood. So I'll try the Graduated Filter moving from right to left, and use the Exposure slider to make the adjustment.

I'll hold down the Shift key as I click and drag to the left side of the image. The Shift key modifier helps me maintain a straight line. I drag about two-thirds through the image because that's the area I want affected. I then click the "−" button on the Exposure slider until I've reduced the exposure to the level I want. I could play with the Brightness, Contrast, and other sliders, but for now, I just need an exposure adjustment. I can hide the dotted lines that indicate the area I'm working on by turning off the Show Overlay checkbox.

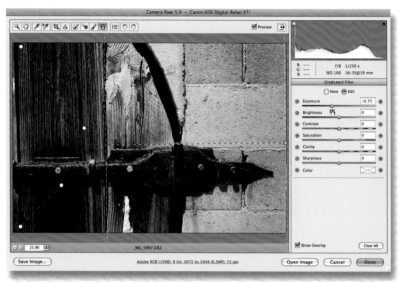

Adjusting the exposure on the right of the image using the Graduated Filter tool

If I want to pull the overlay out a little further, I can click on the red dot and drag. To angle the overlay in a different direction, I drag the dashed line. I could add a second overlay by clicking on the New button above the Exposure slider and clicking and dragging again. I can go back to any of the overlays to re-edit by clicking on one of their dots. Once I've created an overlay, I can change its characteristics by using any of the sliders. The changes I make only apply to the overlay that is active. I can, however, make tonal, color, and detail adjustments all to the same overlay.

For example, if I click on the "+" button for the Color slider, that acts as a warming filter. The more I click the "+" button, the warmer the tone gets. The "−" button cools the affected area making the tones more bluish. But I could choose any color I wanted by clicking on the rectangle box to bring up the Color Picker. This also gives me the option to adjust the saturation of the color I've selected.

A couple more overlays to the corners on the left side create a vignette effect. Pulling the Graduated Filter diagonally for a short distance from each corner allows me to darken smaller areas.

This tool also let me creatively control sharpness. If I wanted to unsharpen a background slightly to de-emphasize it, the Sharpness slider gives me some control to do that. By now, though, you've probably figured out the downside to the Graduated Filter tool. That is, the adjustment affects everything in its path. You can't "skip around" objects. Take my rusty hinge, for example. I couldn't darken the bricks too much because part of the hinge would be affected too. And it would look unnatural to have one half of the hinge a much darker tone than the other half.

To get around this, I could make the graduated tonal adjustment in ACR, and then open the image in Photoshop, select the affected hinge area, and balance it using a selection tool on an adjustment layer. This is a good example of blasting through your global adjustments quickly in ACR, and then moving to Photoshop for the fine-tuning.

One final goodie, you can synchronize your Graduated Filter adjustments over many images. Just open a group of images in ACR, select them all, and then click Synchronize. Choose Local Adjustments from the Synchronize pop-up menu, and your changes will be applied to all the images. Keep in mind, however, that Adjustment Brush modifications, if there are any, will also be synchronized.

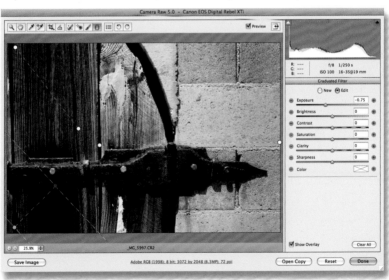

Darkening the corners a tad using the Graduated Filter with reduced exposure

Where to Go from Here

You'll be surprised how often you'll be able to finish all your image editing tasks without opening Photoshop. You can export these gems out of ACR using the Save Image button in the ACR window. You have four formats to choose from: DNG, JPG, TIF, and PSD. If you want, you can give the exported images a new file-name by taking advantage of the File Naming tool in the Save Options dialog box. From here you can use these exported images for Web pages, email attachments, prints, or anything else that strikes you. Those few pictures that you want to take from "great" to "perfect" can move into Photoshop for further adjustment. And that's exactly where we're headed in the next chapter.

Refining Your Image in Photoshop

As amazing as Adobe Camera Raw is for adjusting your photographs, and it *is* amazing, of course there's still a place in the Photoshop workflow for Photoshop itself. The goal here is to take advantage of the unique tools in Photoshop—not out of habit, but rather when the situation demands it. In this chapter, I'll show you some of the best times to use Photoshop.

There are many reasons for this "just enough Photoshop" approach. First, the tools are less intuitive in Photoshop than they are in ACR. Also, you'll notice that your file sizes will increase more than what you've seen in ACR. And finally, file management in Photoshop requires more effort. So, you should save Photoshop for your best images that require its special brand of magic. And once you do move an image into this application, you'll also want to make sure that it's reintegrated into your established workflow.

I begin this chapter by working on a flat image with the Clone tool. A *flat image* is simply a single-layer document. We haven't used this term before because it wasn't necessary. But as we you move into the realm of layers and Smart Objects, your simple files will become more complex in structure. I reserved the cloning task for this stage of the workflow because I think Photoshop's Clone tool is more versatile than the Retouch brush in ACR.

A flat image opened in the Photoshop CS4 interface. "Flat" simply means a single-layer document as you can see in the Layers panel in this example.

After you mess around with the Clone tool, your introduction to layers will arrive via the brand-new Adjustments panel in Photoshop CS4. Adobe designed this panel for people who had avoided using layers in the past for various (and often complicated) reasons. But all of that has changed now. This panel features 15 useful adjustments, including Levels and Curves. And it's much easier to apply these adjustments nondestructively than it was in earlier versions of Photoshop.

Here's a little preview of the features in the Adjustments panel that I hope will prevent you from running for the exit just because I mentioned *layers*. First, when you select one of the adjustments in the panel, Photoshop automatically creates a layer for you. Say you were making a Levels adjustment, for example. Before CS4, you may have made a Levels edit on a flat image (no adjustment layer) by choosing Image→Adjustments→Levels. After you corrected the tone, you probably saved the image and went about your business.

This approach is fine, unless you wanted to go back and reiedit the picture. You can't undo the Levels adjustment that you previously made; you can't even redefine it. All you can do is make another Levels adjustment to the flat image. Over time, this approach can degrade your picture. If instead you created a Levels Adjustment Layer, you could go back to that specific edit at any time and change it without degrading the base image. It's a smarter way to work. The barrier for many photographers, however, is not feeling confident about using layers.

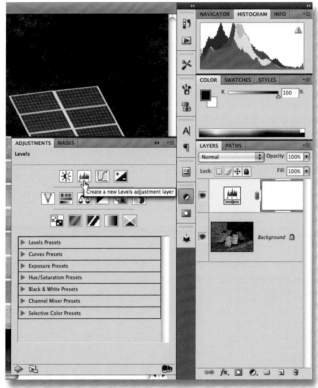

The new Adjustments panel. Notice that when you select an adjustment, such as Levels, Photoshop automatically creates a new layer for you.

> **QUESTION:** Do I Really Need to Use Layers When Working in Photoshop
>
> The short answer is: Yes, you do. By taking advantage of the ability to work inside layers, you give yourself the option to return to your image and rework an aspect of it, without losing the good work you've already one.

The Adjustments panel addresses this concern by providing you with a "best practices" approach to making these edits. Not only does it create the adjustment layer for you, the panel includes presets that will also make the actual adjustment. So, executing a nondestructive Levels Adjustment Layer could be as easy as opening the image in Photoshop CS4, clicking the Adjustments panel, and choosing the Midtones Brighter Levels preset. Easy, and no more guilt about not using layers.

In this chapter, I'll show you how to do that, and more. By the time you finish the chapter, you'll be doing things in Photoshop that you've only dreamed of. You'll have a multi-layered document and even apply a mask to one of those layers. As your confidence grows, so will your willingness to experiment more with layers. And that's exactly what the engineers at Adobe (and I) are hoping will happen.

But this scenario gets even better. Once you've created a layer or two, you'll learn how to create a Smart Object. Smart Objects are what Photoshop expert Deke McClelland calls "magic layers." And he's absolutely right. I'm going to show you how to use Smart Objects for one of my favorite filters: Smart Sharpen. It's a winning combination. And once you master that, you can use the steps I outline for other filters, such as Shadow/Highlight.

I think Smart Objects are particularly useful for sharpening, so that's why I'm starting there with the Smart Sharpen filter. Many photographers save sharpening for the final step of the process, often on a flattened image. However, I think a more modern workflow incorporates sharpening in three places. The first is to compensate for the digital imaging process. That's why I covered the concept of image sharpening in Chapter 5 when we discussed ACR. You need to restore some of the crispness you lost during the digital capture process.

Then, there is creative sharpening. What I mean by that, is you often need to sharpen while performing the various adjustments on your picture. Lots of things degrade the sharpness of a photo, one of which is downsampling. Or you may want to make an artistic choice to adjust the sharpness of an image while you're perfecting its other aspects. For example, say you're making a tonal adjustment, and suddenly you think, "Wow, this would look really cool if it were just a bit

crisper." This is where using a Smart Object to apply this filtering really shines. Because unlike sharpening a flattened image, you can go back and change your sharpness settings at any time without harming the photo. Truly incredible. And I'm going to make it so easy for you to use that you won't be able to resist.

TIP: Open an Image and Join Me

Yes, you could just read this book and enjoy the soothing tones of my encouraging voice. But to truly benefit from this particular chapter, more than any of the others, you ought to open Photoshop CS4 and apply the steps I describe on an image of your own. It can be any old image, really. But I honestly feel that these techniques will make more sense if you're pulling the levers right along with me. Not a requirement, of course, just a thought.

So, how do you begin? Start by opening an image that you've made initial adjustments to in ACR, but that needs further refinements in Photoshop. You'll use the Clone tool, create a Levels Adjustment Layer, and then move into Smart Objects. We'll complete this phase by reviewing the proper way to save and catalog your magnificent photograph.

Touching Up Imperfections with the Clone Stamp Tool

Even though ACR has reasonable cloning capability with its Spot Removal tool, those healing features don't provide nearly the flexibility as the venerable Clone Stamp tool in Photoshop. Generally speaking, if I have some healing to do, such as removing a spot of dust in a blue sky, I take care of it in ACR. But if I need to fix an imperfection near the edge of another texture, I wait to correct it in Photoshop.

TIP: Navigate Around Large Images by Using Birdseye View

In the past, when you were zoomed-in to 100 percent of a large image, you might have had a hard time navigating to different areas of the picture. But no more thanks to the Birdseye View in CS4. When working at a zoomed-in percentage (such as 100 percent), hold down the H key and click. Photoshop will return you to a "fit in window" view and change your mouse pointer to a rectangle. Just relocate the rectangle to the area you want to see zoomed-in, and let go of the mouse button. The image will spring back to the zoomed view in the new location. Try it. It's fun!

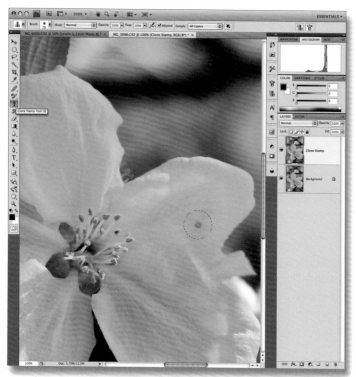

A distracting spot that I want to remove with the Clone Stamp tool.
Notice that I created a new Adjustment layer for this edit.

The Clone Stamp tool works particularly well when you use small brush diameters. You can work precisely, changing your brush diameters and source areas on the fly. A common mistake photographers make with the Clone tool is that they try to work too quickly and with a brush diameter that's too big. I find it's usually better to slow down a bit and clone with smaller brushes. After all, we're not working on hundreds of images. We're refining a picture that we think has real potential for greatness.

Start by creating a new layer for your adjustment. Just right-click the Background Layer icon, choose Duplicate Layer, and name the new layer Clone Stamp. Make sure that layer is selected (it will be highlighted if it is) before going any further. Now examine the area you want to fix. Pay attention to the colors, tones, and textures of the area around the imperfection. Then find another section in the photograph that has similar attributes. Choose a brush size that will let you work precisely. You can pick your brush from the contextual toolbar right above your photograph. From left to right, you'll see an icon for the Clone Stamp tool, a pop-

up menu for brush sizes, a pop-up menu for blending modes, and other settings, including for opacity. For minor retouching, you can use the Normal blending mode at 100 percent opacity.

Then move the cursor to the area you've identified as a good source. If you need to get a better look at it, increase the magnification by choosing the Zoom tool and dragging over the area you want to use. Go back to the Clone Stamp tool, hold down the Alt/Option key, and click the source area. Then move the cursor to the area you want to fix, click, and paint over the imperfection. If you don't like the way your correction looks, press ⌘-Z (Ctrl+Z in Windows) to undo it and try again.

COOL TOOLS

CONTROLLING THE CLONE STAMP OVERLAY

The new overlay feature for the Clone Stamp helps you line-up your correction before applying it. The tool shows you a preview of the correcion as you hover over the area. When you get it lined up, you just click. Additionally, you can take control over this feature so it only appears when you want it.

First, go to the Clone Source Panel and uncheck the box next to Source Overlay under the Clone Source tab. The clone tool will work as it did in the old days with no overlay. But you can now enable the overlay on the fly by pressing Option-Shift (Alt-Shift) to temporarily restore it.

Now you have the overlay only when you want it.

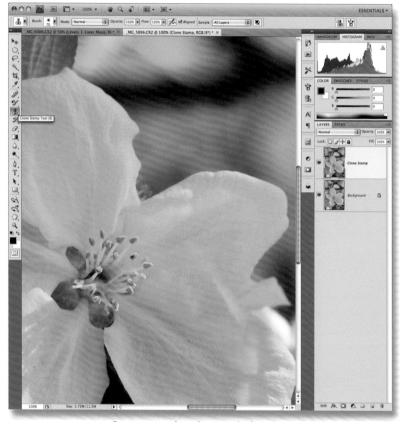

Spot removed, and no one is the wiser.

I recommend that after a little bit of retouching, you resample another area. This prevents what I call the "cloned" look whereby you've duplicated an entire region, pixel for pixel. Very tacky. A good shortcut for changing the diameter of your chosen brush is to use the right bracket key to increase the diameter and the left bracket key to decrease it. Once you finish your correction, zoom in and out so that you can examine it at different magnifications. Sometimes a correction that looks natural at 100 percent looks different at half that size.

How to Save Photoshop Files

At this point, you need to save your document (File→Save). Since you've temporarily wandered outside Bridge and into Photoshop land, you need to make sure your layered document makes it back into Bridge alongside its original.

I recommend that you store the Photoshop versions in the same folder that contains the original shots. Then, open Bridge, sort by Date Created, and the Photoshop file should appear alongside its original raw or JPEG version. One of the things I do with my filenaming system is that I always keep the file number the camera assigned to the photo, even if I add custom text to the filename. It makes it much easier to find various versions of the files published on Web pages, stored on archive drives, or wherever else they may go.

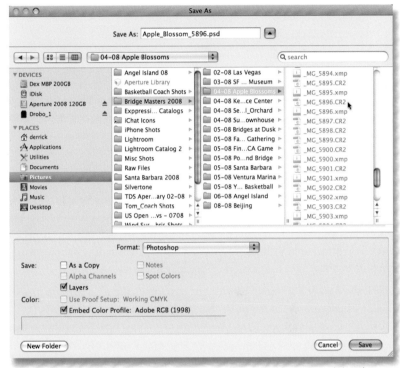

Put your layered file in the same folder as the original image, retaining the
image number. Make sure the Layers checkbox is turned on.

I also create a stack in Bridge with the original file and the Photoshop version grouped together. Just select them both, then press ⌘-G (Ctrl+G) to group them. Once they're grouped, open the stack by clicking the number in the upper-left corner. Click once on the image you want to have at the top of the stack, and then go to Stacks→Promote to Top of Stack. Most of the time, this will be your refined Photoshop file. You can then collapse the stack again by clicking its number.

Create a Stack with your two images so that you have them both available side by side.

Use this organization approach for any file that you move into Photoshop. If you want to go back and work on the file some more, locate it in Bridge, double-click it, and it will appear in Photoshop, just as you left it, with layers intact.

Adjusting Tone with a Levels Adjustment Layer

The Levels adjustment is often a favorite among photographers for adjusting tone in an image. Even though you have Curves in ACR, you don't have Levels. The good news is that in Photoshop CS4, you can use the new Adjustments panel for Levels. I like this addition because it's easily accessible, it includes a handful of useful presets, and it automatically creates an adjustment layer for you.

If you shied away from using layers in the past, now's the time to jump in with both feet. Photoshop CS4 has made this easy by semi-automating the process. I'll make it even easier for you by showing you a few simple tips. The upshot is that you'll be unable to resist taking advantage of this great feature in Photoshop.

Creating the Levels Adjustment Layer

Start by clicking the Adjustments icon to reveal an array of adjustments with presets below them. Click the triangle next to Levels Presets to reveal eight pre-designed settings. If you think one of those choices might be right for your image, click it.

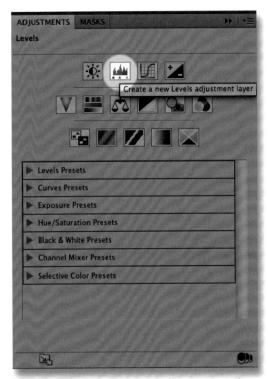

The Levels icon on the new Adjustment panel

Photoshop will create a new layer, apply the adjustment, and show you the newly designed Levels Adjustments panel. If the preset didn't produce the results you wanted, don't worry. We'll have plenty of opportunity to make further tweaks. For example, you can try a different setting now to see whether it works better. As you try them out, you'll see the shadow, midtone, and highlight markers change position beneath the histogram. This helps you understand the nature of the adjustment.

In the bottom-right corner of the panel, you'll see three icons: Previous State, Reset, and Delete Adjustment Layer. You can use these shortcuts to step back, reset your levels altogether, or delete the layer and begin fresh. If you delete the layer, Photoshop returns you to the overview for the Adjustments panel so that you can decide which direction to try instead.

Click the Adjustments layer icon in the default workspace to reveal an array of new tools, including the Levels Adjustments panel that's selected here.

Go ahead and delete the layer (Photoshop might ask you whether you're sure you want to do this), and then click the Levels icon in the Adjustments panel. This creates a new layer, but it doesn't apply any settings. We're going to do that ourselves.

First, let's try the easiest method. Click the Auto button that's right above the histogram in the Levels Adjustment panel. Take a look at your image. Sometimes that's all you need to do.

You can see "before and after" versions of the image by going to the Layers panel and clicking the eyeball icon in the new Levels adjustment layer. Clicking that icon lets you turn off the layer so that you can see the original image, and clicking it again turns the layer back on. What do you think? Is it better with the adjustment? If you still want to play, I have another method for you.

This time, we're going to use one of my favorite approaches, the three eyedroppers. The top eyedropper is for setting the black point, the middle is for setting the gray point, and the bottom is for setting the white point.

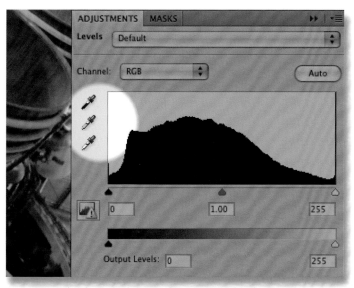

The three eyedroppers for setting the black point,
gray point, and white point.

Click the top eyedropper, look for the darkest area in the photograph, and click it. Then choose the middle eyedropper, look for a midtone, and click it. Finally, choose the bottom eyedropper, look for a bright highlight, and click it. Now take a look at your photograph. Do you like it better than the auto-adjustment version?

If you like the tonal adjustment, but you aren't crazy about the color shift that came along with it (often the color improves, but not always), go to the Blending pop-up menu at the top of the Layers panel that reads "Normal" and choose Luminosity from the bottom of the pop up. This changes the blending mode so that only tone is affected, not color. You can also go the other way and choose the Color blending mode. Now you get the color shift without the tonal change. Pretty cool, huh?

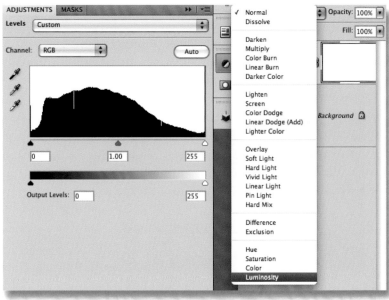

Change the blending mode to Luminosity to prevent color shifts.

Go back to the Normal blending mode for a moment. Let's say you like both the color and the tone of your new adjustment, but you feel that it's just a tad too intense. Click the Opacity pop-up menu and play with the slider. How does the image look at 20 percent, 40 percent, or 80 percent? You'll notice that as you play with these different parameters, the color histogram at the top of the panel is constantly changing. And it's also getting a bit ugly. In that area, you'll see a triangle with an exclamation point in it. If you click it, the histogram will update to reflect your latest settings. Now that looks much better.

You can update the histogram by clicking the triangle.

You've just created a nondestructive Levels Adjustment layer that you can come back to and play with time and time again. (To revisit, just click the Levels icon in your new adjustment layer.) When you select Save (File→Save), Photoshop will recommend that you save in the PSD format with the Layers box turned on. Go with that recommendation to preserve your adjustment layer so that you can come back to it later. Remember to navigate back to the folder where the original version of this image is stored. You want to place this Photoshop version there also so that you can group the two together using Stacks.

If you're feeling good about this, you're going to feel even better soon. Now you're going to create a mask on that adjustment layer to focus your corrections to a specific area. And you know what? It's easy.

Adding a Mask to the Adjustment Layer

Layer masks may sound a bit intimidating, but once you learn a few basics, they actually begin to make sense. We're going to create a second adjustment layer, this time choosing Hue/Saturation from the Adjustments panel. We'll desaturate the entire image so that it appears black and white. Then we'll mask out part of the picture to let the original colors show through. This is a great way to focus attention on a specific part of the composition.

Start by clicking the background layer once to select it in the Layers panel. Then click the Adjustments icon and choose Hue/Saturation. Move the Saturation slider all the way to the left to desaturate the image. It should look like a black-and-white photograph. If you don't see the effect you expected, you might have to move the layer up in the stack. Just drag it to the top of the Layers panel.

Now click on the layer mask thumbnail next to the Hue/Saturation thumbnail in the Layers panel. This "activates" the layer mask thumbnail so that you can do a little selective editing. Go to the Toolbox on the left side of the interface and check that the foreground color is set to black and the background color is set to white. If the colors aren't set in this way, you can set them easily by clicking the Default Foreground and Background Colors button to set them to white and black, and then clicking the toggle icon to the right to switch to black as the foreground color.

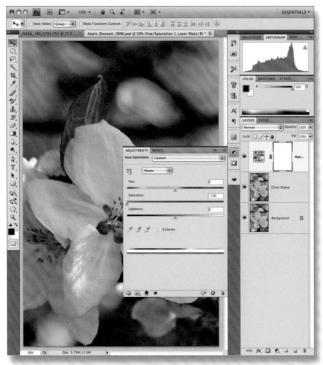

Desaturate the image by dragging the Saturation slider all the way to the left.

Why are you doing this? It's pretty simple, actually. When you're creating a mask, black lets the original image show through and white blocks it out. By default, the mask starts as all white. So if you want to let some of the original image show through, then paint with black.

Set your foreground color to black.

Here's a real easy way to make this stick. Once your foreground color is set to black, click the Brush Tool icon, set a brush diameter, and start painting on your photograph. Everywhere you paint, color will show through. So, painting with black lets the background through, and white blocks it out. If you overpaint an area and need to clean it up, just click the toggle icon to switch your foreground color to white. Painting with white covers up the background.

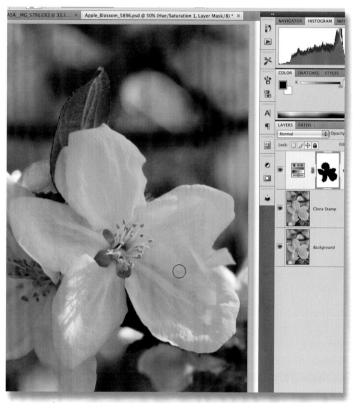

See how painting with black lets the color part of your photo show through the grayscale layer you created?

OK so far? Switch back to black, and then paint an area in your image that you want to be in color. After you think you've got it, try this to get a better look at the layer mask you've created. Press the Alt/Option key and click the mask thumbnail in the Layers panel. That will enlarge your mask so that you can check for areas you've missed. Once you've finished checking, click the Hue/Saturation icon in the Layers panel to return to normal view. Looks pretty good, doesn't it?

You can get a bigger view of the layer mask by Alt/Option-clicking the mask thumbnail in the Layers panel. This is helpful for cleanup.

But there's still one more fun thing to do. With the layer still selected in the Layers panel, go to the Opacity pop-up menu at the top of the panel. If you move the slider to 0, the entire image is pure color as when you started. If you move the slider back to 100, the masked area is in grayscale, with your color area showing through the mask. But if you move the slider in between the two extremes, you can create an artsy antique background that is neither color nor black and white.

Wow! You really look like you know what you're doing! Save your file. You can return to it at any time and play with these settings. You are now fully immersed in nondestructive, layer-based image editing.

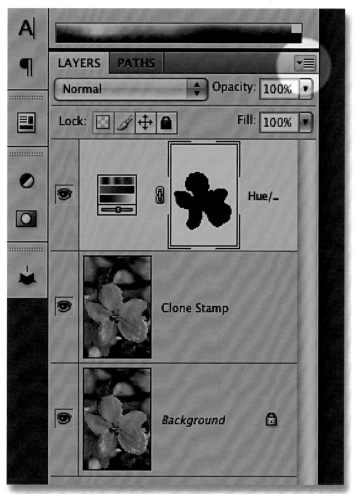

The Layers Panel Menu icon

You can make your thumbnails in the Layers panel bigger by clicking the Layers Panel menu (in the upper-right corner of the Layers panel) and choosing Panel Options from the pop-up menu. You can pick the size of thumbnail that best suits your eyesight. I like 'em big.

A FEW TIPS FOR WORKING WITH LAYERS

The most important tip, and the thing that people often forget, is that you have to have a layer selected in the Layers panel in order to adjust it. So, if you're working away and nothing happens, you probably don't have the layer selected. I know it sounds really basic, but it has happened to us all.

By default, Photoshop automatically creates a white layer mask every time you create a new adjustment layer. If you're not going to use a mask for a particular layer, you can clean up your Layers panel by trashing it. Just select the layer, and then Alt/Option-click the Trash Can icon at the bottom of the Layers panel. The mask will go away. You can always bring it back by selecting the layer again, and then clicking the Add Layer Mask icon at the bottom of the Layers panel. It's the one that looks like a box with a white circle in it.

Nondestructive Sharpening with Smart Objects

Once you've put the final touches on your image, you may want to add a little sharpening. At this point, you're looking at things creatively, so it would be nice to be able to readjust your sharpening choices in much the same way you can change your mind about tone and color corrections using layers. Thanks to Smart Objects, you can do exactly that, by taking advantage of nondestructive sharpening.

Smart Objects are essentially a file within a file, or as I mentioned earlier, a magic layer. You can create a Smart Object from a single-layer image or, as we're going to do here, from a multilayered photograph.

Start by selecting all your layers in the Layers panel. I usually click once on the top layer, and then hold down the Shift key and click the bottom layer. Once you've highlighted all your layers, go to the Layers Panel menu (in the upper-right corner of the Layers panel) and choose Convert to Smart Object. All your layers will collapse and become embedded in the new Smart Object thumbnail that also displays a new Smart Object icon in its lower right-hand corner. This may take a minute or two. As wonderful as Smart Objects are, they can slow things down quite a bit. But this is the price you pay for nondestructive sharpening.

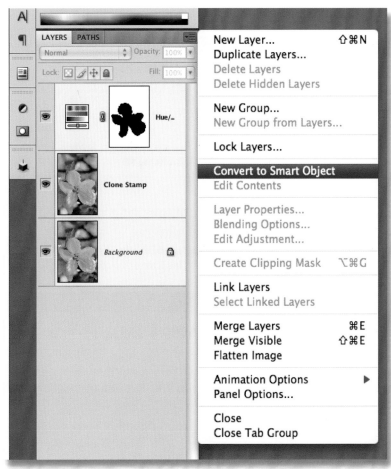

Select all your layers, and then create a Smart Object from the Layers Panel menu.

You'll notice that your Smart Object also has a name attached to it. The name field could be just about anything. Usually Photoshop picks up the name from one of the layers and applies it here. You can double-click the name once to highlight it and relabel it as you wish. I usually add "SO" to the name so that I remember it's a Smart Object.

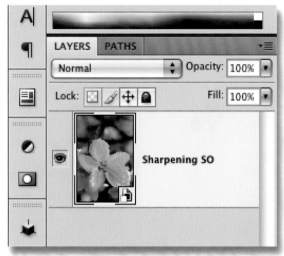

All your layers now reside inside the Smart Object container.

BRIEF DETOUR

OPENING A SMART OBJECT

First, double-click the Smart Object thumbnail in the Layers panel. You'll get a notice from Photoshop about how to save the document going forward. Go ahead and read the notice, but don't worry about it. Click OK.

Photoshop then puts you back inside the Smart Object. Your layers will reappear, and you can make any type of adjustment or readjustment you desire. Once you're finished, close the image by choosing Close from the File menu, or by using whatever method you normally use. Photoshop will ask you whether you want to save the picture. You do! Photoshop is actually saving your changes to memory, not to disk. That's why you'll get a second notice to save again. This time, if you click Save, your changes will be saved to disk too. If you click Cancel, Photoshop keeps the file open, and your Smart Object reappears. Either way, you're fine.

The takeaway here is that once you save an image as a Smart Object, you can get back inside it to make tonal and color changes. Just realize that you're going to get two save messages. The first will be to memory, and the second will be to disk.

As a by-product of this conversion, you need to know that you don't have direct access to the pixels anymore, at least when the Smart Object container is closed. You can test this by going up to the top menu bar, clicking Image, and seeing that Adjustments is grayed out. The same thing goes for painting tools, the Clone Stamp tool, and so forth. Now don't panic! I'll take a brief detour and explain how you can get direct access to the pixels in case you want to go back and tweak a previous adjustment.

Back to Nondestructive Sharpening

OK, back to the task at hand, which is nondestructive sharpening. And it's incredibly easy. With the Smart Object selected in the Layers panel, go up to the top menu bar and choose Filter→Sharpen→Smart Sharpen. You'll be greeted with the standard Smart Sharpen dialog box.

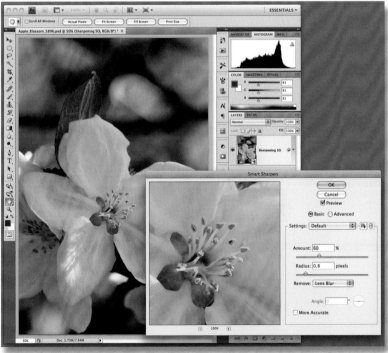

The Smart Sharpen dialog box

Make sure the Preview box is turned on, and click the Basic radio button if it isn't already selected. Jump down to the Radius slider and set it between 0.8 and 1.0. Choose Lens Blur from the Remove pop-up menu if your image originated from a digital camera (and Gaussian Blur if the image is a scan of a photograph), and uncheck the More Accurate box. Now move the Amount slider until you get the sharpening effect you want. Then click OK.

Photoshop applies the filter, and then does a couple of other things. First, you'll see a new filter mask called "Smart Filter" appear below your Smart Object thumbnail. This mask applies to all filters you may use; it isn't like a layers mask that applies to only a specific layer. If you're not interested in masking at this point, you can drag the mask to the little Trash can at the bottom of the Layers panel.

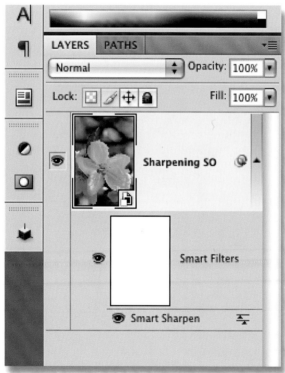

You have a Smart Filters listing in the Layers panel that shows a mask for all your filters, and below it, the listing for your Smart Sharpen filter.

You'll also see a line of text that reads "Smart Sharpen" with an eye icon to its left and a blending icon to its right. If you double-click the text, the Smart Sharpen dialog box reappears, letting you change your settings. If you double-click the blending icon, you get a new dialog box that lets you change your blending options and their opacity. The default blending mode is Normal, but I often prefer to choose Luminosity from the menu because it helps to reduce the color artifacts that are sometimes the by-product of applying a sharpening filter.

You can change your blending option to Luminosity to help control color artifacts.

You've done it! You've applied a nondestructive sharpening filter. When you save the image, use Save As to save it as a Photoshop file with the Layers box turned on. Be sure to give it a unique descriptor so that you can easily distinguish it from the other versions. You don't have to turn on the "Maximize compatibility" checkbox that follows if you're just going to work on the file in Photoshop CS4 on your computer. However, turning on that checkbox does make your image more compatible with older versions of Photoshop and current versions of Lightroom. So, if you plan to use your image in those environments, do turn on the "Maximize compatibility" checkbox.

Also, don't forget to save the image back to the same folder as the original and other versions of this shot. For example, when I now look in Bridge, I see the original raw version of this image, a Photoshop version where I cloned out the spot on the petal, and a multitoned version with a grayscale background. I've grouped all three versions into a Stack. I'm feeling so organized!

What's so great about what you've just done is that you can reopen the file and change your sharpening settings without harming the image's integrity. And if you need to work on any of your adjustment layers, you know how to do that too. Just open the Smart Object and make your changes. In other words, you're in complete control of this image.

Where to Go from Here

If you're not totally excited by this point, you're just not the promising Photoshop geek I thought you were. Because you now know more image editing goodness than most of your friends. But I still have a few goodies for you. In the next chapter, I'm going to show you some specialized uses for these tools to make your pictures look even better. Nothing over the top here; just a little digital polishing.

Photoshop Recipes for Photographers

In much of this book, I've focused on things you can do outside of Photoshop, such as organize your photos in Bridge and perform basic image editing in Adobe Camera Raw. But for some enhancements, you absolutely need to use the powerful tools in the world's leading image editor. This chapter features essential recipes for perfecting your photographs in Photoshop.

Techniques such as whitening teeth and sharpening eyes can serve as the finishing touches to your best images. Once you master the individual steps, you can combine them into groups to address the needs of just about any picture. It's like using a handful of recipes to create a five-course meal. So, let's get cooking!

Portrait Retouching Techniques

Even though you may not be the photographer to the stars, there will be times when you need to touch-up a portrait. These short recipes deal with the basic enhancements you'll have to make most often.

Keep in mind that you can use these recipes in combination with one another to build a more complete makeover. Also, you can use many of these recipes for a variety of tasks in addition to the primary one stated in the recipe. For example, you can use the technique for softening bags under the eyes to correct a hot spot on a shiny forehead.

Regardless of which recipe you're working with at any given moment remember that less is more when retouching portraits.

REMINDER: I'm Presuming the Default Workspace

If you've played around with Photoshop at all, your workspace may not look the same as mine, especially in regard to which panels are open, and whether they are set to icon size, name plus icon, or fully open. I can't predict exactly how your workspace will look, so if you get lost, you can go to Window→Workspace→Essentials (Default) and you should be able to jump in alongside my instructions.

RECIPE 1: Brightening Teeth

A beautiful smile is both endearing and attractive. Here's how to add a bit of sparkle to any cheerful expression.

1. Open the image and zoom to 100 percent so that you can get a good look at the teeth.

2. Go to the Adjustments panel and select Hue/Saturation (it's in the second row). Hold down the Option (Alt) key and drag the white mask thumbnail to the Trash icon at the bottom of the Layers panel.

Choose Hue/Saturation from Adjustments.

3. Click the Targeted Adjustment icon (it appears as a hand with a finger pointing upward) to select it. It turns into an eyedropper when you hover your mouse over the teeth. Pick an area of the tooth surface and then click and drag the dropper to the left. It will desaturate the area you've sampled—in this case, the teeth. Don't worry about the effect of this adjustment on the rest of the image. Focus on the teeth until you like what you see.

The Targeted Adjustment tool

4. Option/Alt-click the Layer Mask icon (at the bottom of the palette). Photoshop will create a black layer mask thumbnail to the right of your Hue/Saturation thumbnail. It will also temporarily hide your adjustment.

5. Set the foreground color to white in the Tools Panel.

6. Click the Brush icon in the Tools palette or just press "B" to get the Brush tool. Choose an appropriate brush size and paint the teeth to let the adjustment show through. You may want to use a soft-edged brush for a more natural look. You're literally painting away the yellow coloration.

Paint on the tooth surface with your brush to reveal the whitening effect.

7. If you paint outside the lines and need to correct a mistake, switch the foreground color to black (by pressing the X key) for any touch-up work (black hides the adjustment).

8. Toggle the eyeball icon off and on in the adjustment layer to check your work.

9. If you find that you were a little overzealous in your dental work, resulting in ultra-bright teeth, you have a couple of options. You can go to the Opacity slider and dial it down until you get a more natural look. Or you can double-click the Hue/Saturation thumbnail and play with the adjustments there.

10. Save the image as a layered PSD file and place it in the same folder as the original. Open Bridge, select both images, and group them together in a Stack.

T I P : Recipe Variation

This technique is also excellent for brightening the whites of the eyes and removing redness (ruddiness) from skin tones.

RECIPE 2: Touching Up Blemishes

Even on portraits that don't need touch-ups, you may want to remove a blemish or two. Often, this is all you need to do. And the best part is, it's easy!

1. Create a duplicate of the background layer by choosing in the Layers panel, and pressing ⌘-J (Ctrl-J) or choosing Layer→Duplicate Layer.

2. Select the Spot Healing brush from the Tools panel.

3. Select a brush diameter from the Control panel that is a little larger than the blemish you want to remove. You also can use the right and left bracket keys to change the brush diameter on the fly.

4. Click the blemish once to remove it. If you don't like how Photoshop corrects the imperfection, switch to the Healing brush, and sample an area that you want to use to correct the blemish by Option (Alt)-clicking. In the case of a portrait, look for a skintone similar to the area you are correctiing, and set that as your sampling area.

Choose the Spot Healing brush from the Tools panel.

RECIPE 3: Darkening or Lightening Facial Features

Although the Dodge and Burn tools have dramatically improved Photoshop CS4, I still think these are difficult tools for creating subtle results when lightening and darkening areas of the face. Instead, I prefer to create a neutral fill layer by using the Soft Light blending mode and paint with the standard brush tool. Not only do I get more natural results, and better control than I would with Dodge and Burn but the process is nondestructive, letting me go back and rework the adjustments at any time.

1. From the main menu choose Layer→New Layer.

2. Select Soft Light for the mode.

Create a New Layer and choose Soft Light for the mode.

3. Turn on the "Fill with Soft-Light-neutral color (50% gray)" checkbox.

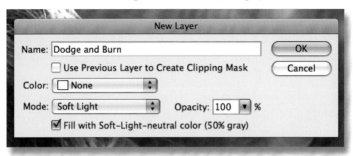

Turn on the "Fill with Soft-Light-neutral color (50% gray)" box.

4. Click the Brush tool in the Tools panel and select a soft-tipped brush from the Control panel. Set the brush opacity to 15 percent or 20 percent.

5. Press the D key to make black your foreground color.

6. Brush over the areas you want to darken.

7. Press the X key to toggle your foreground color to white.

8. Brush over the areas you want to lighten.

Check your work often by toggling the eyeball icon off and on for this adjustment layer. Also, if you overlighten or overdarken, press the X key again to paint back in the opposite tone. Remember to save your work as a Photoshop layered file. And keep in mind that the best tonal adjustments, especially those you make to the face, are subtle. So, don't overdo it!

T I P : High Performance Zooming

Zooming in Photoshop CS4 has improved dramatically. Simply press the Z key and click and hold on the area you want to zoom in on. Watch as you smoothly zone in on the area you want to magnify. To zoom back out, press the Alt key while you click-hold your mouse.

RECIPE 4: Softening Skin

Like so many portrait retouching techniques, you can overdo skin softening to the point of plasticity. But that doesn't mean you should not smooth out excessive texture when necessary. This technique will help you create more flattering skin without sacrificing the subject's general appearance.

1. Create a duplicate of the background layer (Layer→Duplicate Layer or use the keyboard shortcut ⌘-J/Ctrl-J). Drag the duplicated layer up to the top of the layer stack if you've made other adjustment layers.

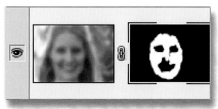

Duplicate the background layer and a black layer mask.

2. Add a 25-pixel Gaussian blur (Filter→Blur→Gaussian Blur) to the layer and set the opacity to 35 percent.

3. Hold down the Option (Alt) key and click on the Layer Mask icon to create a black layer mask.

4. Set your foreground color to white, and use a largish (start with 70 pixels), soft brush to paint all of the areas you'd like to soften. Avoid the eyes, lips, nostrils, eyebrows, hair, and other features that should remain sharp.

5. Check your coverage by Option (Alt)-clicking the Layer Mask icon to display the mask on the image. Fill in any areas that you missed.

Check your coverage by Option/Alt clicking on the layer mask to enlarge it.

RECIPE 5: **Brightening Eyes**

Photographers who prefer existing-light portraits often have to deal with eyes that are a tad darker than they'd prefer. This is a common problem when you're not able to add fill flash or use a reflector. Here's an easy way to lighten up shadowy eyes.

1. Create a duplicate of the background layer. (Layer→Duplicate Layer or use the keyboard shortcut ⌘-J/Ctrl-J).

2. With the layer selected, switch from Normal mode to Screen mode. The entire image will brighten.

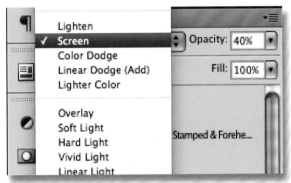

Change the Mode to Screen with a starting Opacity around 40 percent.

3. Option (Alt)-click on the mask icon to create a black layer mask.

4. Set the foreground color to white.

5. Choose an appropriately sized brush and paint the eye area.

6. The effect will be too strong, but you can tone it down by moving the opacity slider down to around 25 percent to 40 percent.

RECIPE 6: Sharpening Eyes and Eyebrows

Even though you set your lens to focus on the eyes, sometimes they aren't as sharp as you'd like them. Here's an easy way to bring some clarity to the windows to the soul without compromising the rest of the image.

1. Create a duplicate of the background layer (Layer→Duplicate Layer or use the keyboard shortcut ⌘-J/Ctrl-J).

2. Apply a healthy dose of Smart Sharpen (Filter→Smart Sharpen): set the Amount to 80 percent, set the Radius to 0.8, and set the Remove option to Lens Blur.

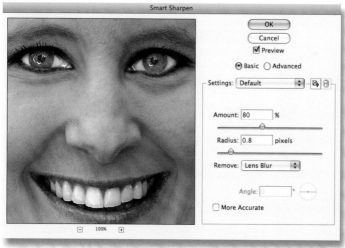

The Smart Sharpen dialog box.

3. Option (Alt)-click the mask icon to create a black layer mask.

4. Set the foreground color to white.

5. Choose an appropriately sized brush and paint the eye area.

6. Adjust the effect by moving the Opacity slider in the Layers panel.

RECIPE 7: Softening Dark Circles Under the Eyes

Most subjects will have some darkening under the eyes. Generally speaking, I think it looks unnatural to remove this characteristic completely. But you can do your subject a great service by softening those "bags under the eyes."

1. Create a duplicate of the background layer (Layer→Duplicate Layer or use the keyboard shortcut ⌘-J/Ctrl-J).

2. Click the Patch tool in the Tools panel. It's in the same cluster as the Spot Healing brush, Healing brush, and Red Eye tool. Check the Control panel to ensure the source radio button is selected.

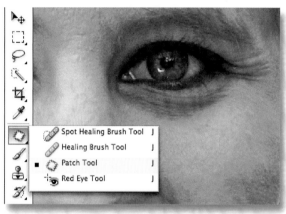

Select the Patch tool.

3. Carefully draw a selection circle around the darkened area. Then drag the selection to an area of skin that has the tonality you want.

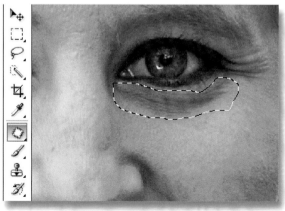

Select the area you want to adjust.

4. At this point, the correction will look unnatural. But you can bring some reality back to the situation by selecting the Fade command (Edit→Fade Patch Selection). Move the slider so that it sits between 40 percent and 60 percent to restore some of the original tonality.

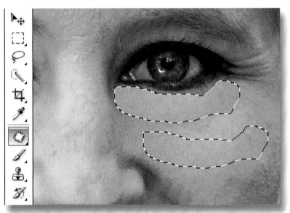

Click and drag to an area that will serve as the source
for the adjustment.

5. Once you're pleased with the correction, press ⌘-D (Ctrl-D) to deselect the area.

This technique doesn't completely remove dark circles under the eyes, but it does soften them dramatically. You can also use this recipe to correct hot areas on the forehead, and a variety of other imperfections.

> **TIP:** Turn off Marching Ants to View Your Correction
>
> If you want to see how your correction looks without the marching ants but without getting rid of your selection, press ⌘-H (Ctrl-H) to hide the selection outline. Press the keystroke again to bring it back.

RECIPE 8: Bumping Up Contrast with Unsharp Mask

Sometimes we look at our portraits, and they seem to need just a little "pop." Here's a technique that uses, of all things, the Unsharp Mask filter. But the settings you use to bump the contrast will be different from the settings you've used with this filter previously.

1. Create a duplicate of the background layer (Layer→Duplicate Layer or use the keyboard shortcut ⌘-J/Ctrl-J).

2. Open Unsharp Mask (Filter→Sharpen→Unsharp Mask).

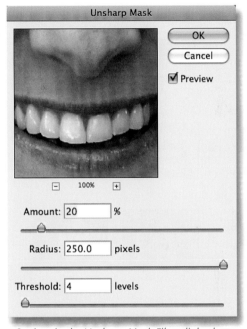

Settings in the Unsharp Mask Filter dialog box

3. Move the Radius setting all the way over to 250 pixels.

4. Set the Threshold to 4.

5. Move the Amount slider to somewhere in the neighborhood of 20.

6. If parts of the image gain too much contrast, such as the hair, use the History brush to restore those areas to their previous state.

This technique works best on well-exposed portraits in flat light. Once you apply the technique, the "before" image will almost always look too flat.

RECIPE 9: Stamping Layers to Pull Your Adjustments Together

After you've created a few adjustment layers, you may want to bring all of those great improvements together into one layer. Stamping lets you merge the contents of those lower layers into a target layer while leaving the other layers intact.

The beauty of this technique is that you have one meta-adjustment layer that you can view and even tweak, such as change its opacity, yet you don't lose the flexibility of returning to the other layers by creating it. So, if you want to go back and further adjust one of those lower layers, just delete the stamped layer, experiment some more with the lower layer, and then create a new stamped layer.

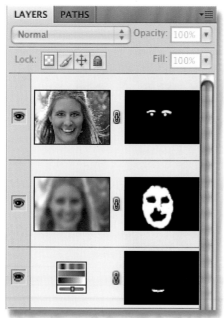

You can select a multiple adjustment layers.

You can create a stamped layer by selecting a group of layers, and then pressing the Shift-Opt-⌘-E keys on the Mac or Shift+Alt+Ctrl+E keys on Windows. Photoshop will roll up all of those individual adjustments into one tidy layer at the top of the stack.

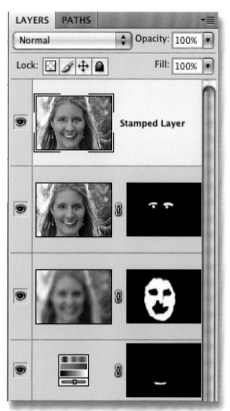

Then create a stamped layer that incorporates all of those adjustments.

Adjustments in the World Around Us

I'm going to move away from portraits now and take a look at the world around us. I'll be honest: Most of the corrections I need to make for landscapes and architecture I can accomplish in ACR. But sometimes only Photoshop can provide the finishing touch. In this section, I'll share some of my favorite recipes for just those times.

RECIPE 10: Correct Architectural Distortion

Buildings are great subjects and often distinctive icons for place and time. But when we photograph them with our DSLRs and compact cameras, we typically have a fair amount of distortion to cope with. This short recipe will help you square things up in no time.

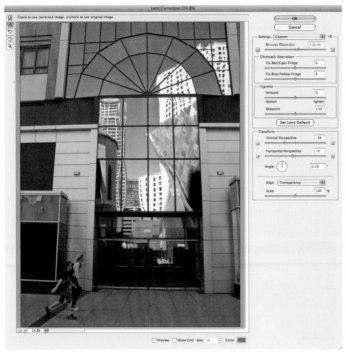

"Falling back" distortion of building façade

1. Create a duplicate of your background layer (Layer→Duplicate Layer or use the keyboard shortcut ⌘-J/Ctrl-J).

2. Select the Lens Correction filter from the Filter menu (Filter→Distort→Lens Correction). Make sure the Edge pop-up menu (at the bottom of the interface) is set to Transparency.

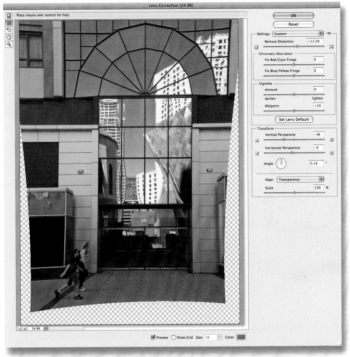

Minimize distortion with the Lens Correction filter.

3. In most instances, you'll start with the Vertical Perspective slider in the Transform menu. Move the slider to the left to correct a building that's falling backward.

4. You may need to play with the Horizontal Perspective slider as well, to square up the building so that it's facing the horizon correctly.

5. Use the Straighten tool (second from the top on the toolbar on the left side of the interface) to straighten horizontal or vertical lines. Just hold down your mouse button and drag along a straight line in the composition. Photoshop will make the correction for you.

6. Once you've compensated for the distortion, click OK. You'll probably be missing some information in the corners of the composition (represented by a checkerboard) as a result of the correction.

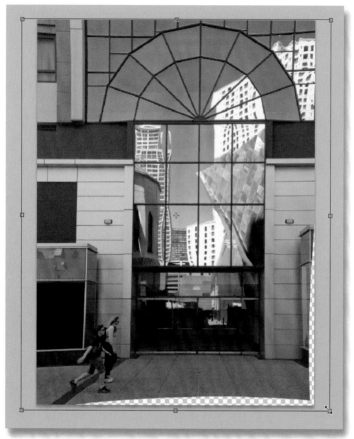

Finish the adjustment with the Free Transform tool.

7. With the layer still selected, open Free Transformation (Edit→Free Transform). Drag the handles on the Free Transformation selection to pull the image outward and eliminate the checkerboard areas. You can also use simple cropping to clean up your final composition.

Save your image to the same folder as the original, and stack both this image and the original together.

RECIPE 11: Retrieving a Blown-Out Sky

Speaking of buildings, sometimes you have a great shot of a structure, but the sky in the composition is much brighter and lacking detail.

A blow-out sky lacks drama.

Ideally, if you have the time, you should take a second shot in exactly the same camera position (yes, I'm saying *tripod*), and expose that second exposure for the

sky. But if you can't do that, make sure you're shooting in raw and try this easy recipe.

This technique works particularly well with buildings and other structures that have clean, defined lines.

1. In Bridge, create a duplicate of your image by choosing Edit→Duplicate or pressing ⌘-D (Ctrl-D).

2. On the duplicate, reduce the exposure in ACR to bring out the sky. Don't worry that the rest of the picture goes dark.

3. Open both the original image and the duplicate in Photoshop.

4. Shift-drag the bright-sky version on top of the darkened-sky duplicate. This will create a new layer and align the two shots. (CS4 uses Tabbed Document Windows to manage all of your open files. To drop one image on top of another, just drag the image up to the tab and hover your mouse over it; Photoshop will switch to that window so that you can drop your photo onto the image residing there.)

5. Double-click the layer thumbnail with the blown-out sky and find the Blend If box.

6. Choose Gray from the Blend If pop-up menu, if it isn't already selected.

7. Move the highlight marker on the top slider a little to the left. You should see your sky magically appear with the properly exposed foreground.

Using the Blend If technique helps you bring back the missing impact.

8. Save your image as a layered file in the same folder as the original. Then stack the layered file and the original together in Bridge.

You can use this technique with two separate images, a line drawing with a white background, or just about any image in which you want to eliminate the white area and let the information below show through.

RECIPE 12: Applying a Color Wash to an Object

The world is a colorful place, but it doesn't always present us with the exact look we want. You can play with the color in an image by using the Color Replacement tool. (I think the name of this tool is a bit misleading. It is really a "color wash" that lets you apply a light tint to an object.)

This technique has its good points and its disappointments. On the positive side, it retains the texture beneath while color-washing the sampled area, so you can literally "see through" the adjustment you make. It also lets you work on an adjustment layer, so you stay in a nondestructive workflow. On the negative side, as I mentioned earlier, the Color Replacement tool usually doesn't present you with the exact color you chose as your replacement. In my experience, you get a lighter version of what you picked. That being said, I still find it handy for applying a tint to objects.

1. Duplicate the background layer Alt-⌘-J (Alt-Ctrl-J) and rename the new layer something like "Color Wash." (Holding down the alt key while you use the keyboard shortcut brings up a dialog box where you can immediately type in the name.)

2. Click the Eyedropper tool, and sample the area you want to replace.

3. Switch the foreground and background colors (you can press the X key do this).

4. Choose the color you want to use as the guide by sampling or using the color picker.

5. You now have the color you want to replace as the background color, and an approximation of the color you want to replace it with as the foreground color.

6. Use the Quick Selection tool to select the area you want to work on. You don't have to do this step, but I've found it's easier to "paint inside the lines" when I use it.

7. Select the Color Replacement tool and the tip size you want from the Control panel. I usually go with a large tip so that I can cover areas quickly.

To change the color of the kayak, set up the Color Replacement tool.

8. Set the Blending mode to Hue.

9. Set the Sampling Option to Background Swatch.

10. Set the Limits option to Find Edges.

11. You can leave Tolerance at 100 if you're getting the coverage you want. If you find that any nearby colors are being replaced too, you might want to lower the Tolerance to 40 or less.

12. Now it's time to paint. How does the color look? If it's not right, now's the time to change it. Undo your painting, choose a new color, and paint again.

Then just paint the new color on.

13. You may need to resample the color you want to replace a few times during this process. It's better to sample often and keep the tolerance tight, rather than sample just once with a loose tolerance (40 more). You'll have less to clean up this way.

14. Work carefully and with some patience, and you'll be rewarded with a high-quality adjustment.

And since your color change is on a layer, you can turn it off anytime you want. Keep in mind that you have to have a color to wash. This won't work on pure white areas. This tool also doesn't work in Bitmap, Indexed, or Multichannel color mode.

RECIPE 13: Changing the Color of an Object (More Flexible, but More Elaborate)

If you're not interested in color tinting, but instead you want to make an accurate color replacement, this technique will put you in business. This is the most elaborate of the recipes for changing the color of an object, but it's also the most powerful.

You'll begin by using the Color Replacement command. It has its strengths and weaknesses. Its strength is that it gives you a lot of control to replace one color with exactly the other color you want. Its weakness is that it won't let you do this on an adjustment layer. But I have a bit of a workaround for you (that I learned from Katrin Eismann in her book, *The Creative Digital Darkroom*), so you can maintain your nondestructive workflow.

1. Open your image. You may want to select the area you're going to work on with the Rectangular Marquee tool so that you don't accidentally adjust an area you want to leave alone.

2. Choose Replace Color (Image→Adjustments→Replace Color).

Choose Replace Color to begin.

3. Click the eyedropper in the upper-left corner and click the color you want to replace. Make sure the Selection radio button is active so that you can see the area you've chosen. The color you've picked to replace will appear in the Color box on the upper right.

4. Now click the lower Result box so that you can choose the color you want to serve as your replacement.

Select the color you want to replace in the Selection box, and then choose the new color in the Replacement box.

5. The new color will appear in the image. Zoom in to make sure there aren't any fringing remnants with the old color. If there are, click the top-middle eyedropper (Add to Sample) and that should clean up the image. Zoom back out.

6. You can experiment some more with your new color by adjusting the Hue, Saturation, and Lightness sliders. Note the settings that you use for these adjustments. (This is very important because you'll need these settings later.) Once you have things the way you want, click Save to save these settings to your hard drive. Remember the location so you can find them again. (The filename will have an *.axt* extension.)

7. Click Cancel to exit the dialog box without actually applying the changes.

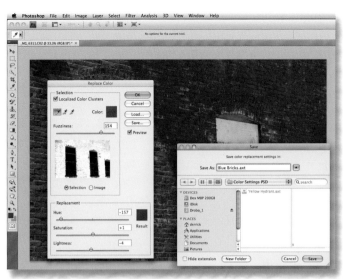

Don't click OK! Instead click the Save button to save your settings.

8. Go to Color Range (Select→Color Range). Click the Load button and navigate to the file you saved. Click OK.

9. Click the Hue/Saturation Adjustment. The areas you saved will automatically be selected and replaced.

After you've saved your settings and loaded them in the Color Range dialog box, go to the Adjustments palette and select Hue/Saturation.

10. Fine-tune by adding the Hue/Saturation/Lightness settings you noted from the Color Replacement dialog box.

Enter the HSL numbers you noted back in the Replace Color dialog box.

11. You'll now have the same color change you had in the Color Replacement dialog box, except this time the color change is on an editable layer.

You now have a separate adjustment layer for your replaced color.

Essentially you've used the Color Replacement dialog box to build your mask and determine your settings. By clicking Save, you saved the mask and some of the color setting. By loading the information into the Color Range dialog box, you've made these settings available to you in the Hue/Saturation Adjustment control. All you had to do was add the exact setting for Hue (and Saturation and Lightness, if you used them).

This is one of the more elaborate recipes in this chapter, but it is quite powerful. If you don't need this much control, Recipe 14 may be more to your liking.

> **TIP :** Rotating an Image on the Fly
>
> You can rotate a picture by simply pressing the R key and dragging the mouse in any direction.

RECIPE 14: Changing the Hue and Saturation of an Object (The Easy Method)

You're going to love this approach because it's the model of simplicity. It's not as powerful as Recipe 13, but sometimes it's all you need.

1. Open your image, and then click the Adjustments icon and choose Hue/Saturation from the menu that pops up.

2. Click the Targeted Adjustment icon once to select it, and then hold down the ⌘ (Ctrl) key and drag sideways on the color you want to change. (Holding down the ⌘ or Ctrl key changes the hue of the image; without a modifier key it will change the image's saturation.)

Hold down the ⌘ (Ctrl) key and try the Targeted Adjustment tool.

3. Once you find the color you want, let go of the mouse. Then drag again without the ⌘ (Ctrl) key to adjust the saturation.

Depending on your image, the results may not be as accurate as the more elaborate approach in Recipe 13.

4. You're done! Save the image as a layered Photoshop file.

I told you this one was easy!

Finishing Touches

These nifty techniques let you finish off your images in a variety of ways, from a virtual matte frame, to Web preparation, to panoramas and depth-of-field merges.

RECIPE 15: Creating a Virtual Custom Matte

You can quickly build a virtual matte for framing your image on the Web, or even for printing it out. Essentially, all you're doing is adding a layer and using Layer Style to create your virtual frame.

1. Open the image and duplicate the background layer (Layer→Duplicate Layer or use the keyboard shortcut ⌘-J/Ctrl-J).

2. Increase the Canvas Size by 20 percent in the color of your choice (Image→Canvas Size).

3. Add the Inner Shadow Layer Style (Layer→Layer Style→Inner Shadow).

4. Turn off Global Light and use the Normal blend mode.

5. Set the sliders for Opacity, Distance, Choke, and Size to what looks good to your eye.

6. Add Inner Glow if you want a little edge.

Save the image as a Photoshop layered file.

A virtual matte for your photo.

RECIPE 16: Automating Panorama Merging

Merging a series of images into a panorama is one of the most exciting ways to show the breadth and detail of a location. And thanks to the superlative merging tools in Photoshop CS4, panoramas are as easy to build as they are enjoyable to view.

Since managing the assets of a panorama is one of the challenges of working with panoramas, we're going to begin in Bridge and take advantage of its organizational tools. Then we'll use Bridge and Photoshop together to merge our images. Here's how it works.

1. Through Bridge, locate the folder that contains the images you'll merge together.

2. Select all of the assets by clicking the first photo in the series, holding down the Shift key, and clicking the last photo in the series.

3. Go to Stacks→Auto Stack Panorama/HDR. Bridge will examine your images and will put the ones it can use together into a collapsed stack.

In Bridge, select your images and choose Auto-Stack Panorama.

The shots required to merge the panorama will be placed in a stack.
Anything unnecessary will be left out of the stack.

4. You don't even have to open the stack at this point. Bridge and Photoshop will do the heavy lifting. Just click the stack once to select it, and then choose Process Collections in Photoshop (Tools→Photoshop→Process Collections in Photoshop).

Click on the stack and choose Process Collections in Photoshop.

5. Photoshop will open and process the images. When it's finished, it will save them as an assembled PSD file back to the same folder as your stack. (If you

look for the assembled panorama in Photoshop at this point, don't be shocked if nothing is there. Photoshop has moved it back to Bridge.)

6. You can stop at this point and view your panorama in Bridge by clicking the thumbnail of the panorama and pressing the spacebar. This will display the panorama in full-screen mode. You can click the image to go to 100 percent view and examine its details. Navigate by clicking and dragging. You'll have fun with this because it'll be the first time you've seen your images assembled into a wide view.

7. If you want to work on the images some more, press the spacebar again to go to thumbnail mode. Double-click the thumbnail to open it in Photoshop. You'll see your complete image and all of its layers.

Your merged panorama will be a layered document.

8. Flatten the document (Layer→Flatten Image) so that you can play without having to manage all of the layers that were merged together.

9. Save the flattened document (using Save As) and give it a new name, such as *Panorama_flatten.psd.*

10. You can clean up some of the ragged edges at this point. First, duplicate the Background layer.

11. Go to the Free Transform tool (Edit→Free Transform), and pull the corner handles until your panorama fills the frame. Double-click to apply the adjustment.

Flatten the layers, duplicate the Background layer,
and apply Free Transform.

12. Apply any additional tweaks that are necessary using the Adjustments panel.

13. Save this document (using Save As) as a layered document so that you can go back and make further adjustments if necessary.

As a finishing touch, I usually flatten again, apply some sharpening, and save the image as a final document for display. I have my other working versions organized neatly in Bridge, so if I want to, I can always go back and play some more with any of them.

RECIPE 17: Extending Depth of Field by Stacking Images

You can extend the perception of depth in a photo by taking advantage of the blending technology in Photoshop CS4. Essentially, instead of taking just one shot of a subject, you take a short series of shots, each one focusing on a different area. Then, in Photoshop, you use Auto-Blend to merge these individual shots into one image that appears to have extended depth of field.

1. With a digital camera, record a series of photos, focusing on different areas for each shot. I recommend a tripod when possible.

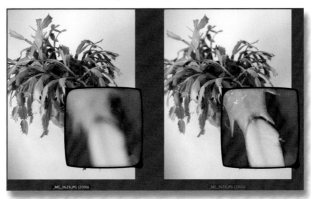

By moving the focus for each shot, you can provide lots of information for Photoshop to blend together.

2. Review your images in Bridge, then open them as a group in Adobe Camera Raw. Make your basic image adjustments. Click the Done button.

3. Now back in Bridge, select all of the images your want to blend. Open them in Photoshop as a layered document (Tools→Photoshop→Load Files into Photoshop Layers).

From Bridge, load the individual shots as layers into one Photoshop document.

4. In Photoshop, select all of the layers, then choose Auto-Align Layers (Edit→ Auto Align Layers). Use the Auto option. Click OK.

5. After aligning is finished, leave the layers selected, and choose Auto-Blend Layers (Edit→Auto-Blend Layers).

After you've auto-aligned the layers, auto-blend them.

6. In the dialog box, choose "Stack Images" and select, "Seamless Tones and Colors." Click OK.

Choose Stack Images from the Auto-Blend Layers dialog box.

7. Your image now has the perception of extended depth of field. Save the layered document in the same folder as the originals. just in case you need to return to it.

The final image will combine the best data from all the layers that were blended together.

8. If you'd like, you can flatten the image and save a copy of it to any format you wish.

Generally speaking, this approach will provide you ith a fairly clean image that requires little or no touch up. In my experience, the results are sometimes unpredictable. Usually, however, I get a final image that I like. I have noticed that my odds of liking the finish product increase if I auto-align before blending.

> **TIP:** Open Multiple Images as Tabs in CS4
>
> Photoshop's new interface enables you to work with multiple images without having a bunch of windows to manage. The CS4 workspace creates a tab for each image you open. To bring a photo front and center, click on its tab. To close the picture, click on the X in its tab. If you want to combine two images, drag the one picture up to the tab of the other, wait until Photoshop changes views, and then drop the image as you normally would do.

RECIPE 18: Optimize Images for the Web Without Losing Copyright Information

When you publish your images on the Web, or in any other electronic format, it's important that your name and copyright information are included.

In past versions of Photoshop, the Save for Web function did a great job of optimizing images for display, but would strip out valuable metadata in the process. Adobe fixed this shortcoming in CS4. So, here's the workflow, from start to finish, so that you can ensure that your name and copyright information travel with your images.

1. Connect your memory card reader to your computer, insert the memory card, and open Bridge.

2. Choose Get Photos from Camera (File→Get Photos from Camera), and make sure the images you want to download are selected.

3. In the Apply Metadata area, select Basic Metadata from the Template to Use pop-up menu. Enter your name and copyright information. If you've created a custom metadata template, use it (see Chapter 2 for more information).

4. Either way, ensure that the Creator and Copyright fields have your personal information in them. Click Get Photos to download the images.

5. When you're ready to publish one of those pictures on the Web, open it in Photoshop. If you follow the workflow of this book, you'll do your basic processing in ACR (see Chapter 4) and then choose Open Image from ACR to view the picture in Photoshop.

6. Once you're in Photoshop, you can do more work. Once you're satisfied, select Save for Web & Devices.

Choose Save for Web & Devices.

7. In the dialog box that pops up, choose Copyright and Contact Info from the Metadata pop-up menu.

Select the appropriate metadata setting.

8. Make any other settings that you need, and then click Done.

Your image will be optimized for the Web, and the original creator and copyright information you entered way back in Photo Downloader (Get Photos from Camera) will be included with the file.

You can apply this technique to any photo you've opened in Photoshop. If the Creator and Copyright fields haven't been previously added (ack!), you can add them manually. In Photoshop, open File Info (File→File Info), click the Description tab, enter your information in the Author and Copyright Notice fields, and click OK. Now when you use the Save for Web & Devices feature, Photoshop will save the text you entered along with the file.

You're a Photoshop Artist; Now What?

Your Photoshop chops have just received a major upgrade. In fact, you should be able to make just about any basic correction you'd ever need to make to an image. So, now what?

Maybe it's time you make a print—a nice, big, beautiful print. If that sounds like a good idea, read on, because that's exactly what we're going to do next.

Printing

USING PHOTOSHOP TO CONTROL
YOUR PRINTMAKING

Many photographers, myself included, believe you can't really evaluate an image until you see it on paper. Prints reveal the characteristics of photographs in much the same way as face-to-face conversations reveal the characteristics of people. And by studying the subtleties in a print, you'll often find ways to improve your photograph.

Yes, it's true—a print has personality. Digital images tend to have a predictable feel when displayed with the steady glow of a backlit computer monitor. Prints, on the other hand, can be made on different types of paper and viewed under a variety of lighting conditions. An image may look one way when printed on a cool, glossy surface, and then surprise you when rendered on a warm matt stock. These variables add both to the excitement of working with this medium, and sometimes, the frustration too.

People like looking at prints, but not everyone likes making them. And if you've endured more frustration than joy when trying to produce an enlargement, you many fall into this category too. To be quite honest, Photoshop itself has been part of the problem. The print dialog box can be an intimating place if you're not confident about the settings to use.

I think this brief chapter will change that. I'm going to show you the basics for making beautiful prints without wasting ink, paper, or your time. Once you have confidence in the process, my guess is that you will want to make more prints. And as a result, become a better photographer in the process.

Calibrating Your Monitor

The process begins with calibration. The number-one complaint I hear from photographers about printing is that the image they see on the screen doesn't match what comes out of the printer. Sure, a backlit image and an image you view on a reflective surface are inherently different in many ways. But you can take a big step toward minimizing those discrepancies by calibrating your monitor and then passing that information correctly to the output device.

Calibrating your monitor simply means you want it to display colors and tones so they match the standard settings used for output, including luminosity and color. By standardizing your settings through calibration, you'll have more confidence that the edits you make to the photos onscreen will be reflected similarly in the print. Keep in mind that a calibrated monitor is only part of the equation. Your output device needs to accurately interpret the information you send to it. But good color management begins with the monitor.

If you're already using a screen calibration device such as Pantone's huey ($89; www.pantone.com) or X-Rite's Eye-One Display LT ($169; www.xrite.com), you're in great shape. But if you aren't using such a device, don't fret. There are a few workarounds for both Mac and Windows users that can help you calibrate your display (while you save up for a better solution). They aren't as accurate, or even as easy, as a good colorimeter, but they're free.

Color management accuracy	Mac OS X	Windows XP, Vista
Fair	Stock monitor profile in Display Preferences pane	Stock monitor profile in Display Properties pane
Better	Built-in monitor calibrator in Display Preferences pane	Third-party software such as Adobe Gamma
Best	Hardware colorimeter	Hardware colorimeter

Monitor calibration options

Calibrating on Mac OS X

Mac OS X includes some handy built-in tools that can get you off to a good start. A handful of preset monitor profiles are available in the Display Preferences pane. Go to System Preferences, click Displays, and then click the Color tab. You'll see a list of profiles you can use for your photography, such as Adobe RGB.

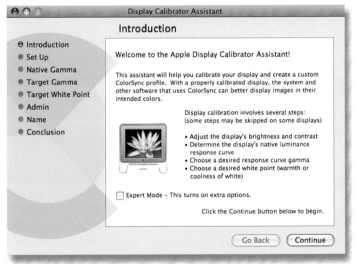

You can use the calibration helper in Mac OS X if you don't have a colorimeter available.

You can also create your own profile. While you're still in Displays, click the Calibrate button. Your Mac will walk you through the basic steps of visual color calibration. It's not as accurate as the mechanical calibration a colorimeter can perform, but it's a giant step in the right direction.

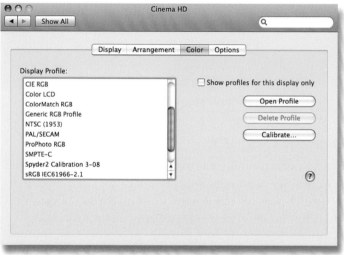

A list of color profiles in the Displays dialog box for Mac OS X.

After you finish the process, you'll have a new color profile for your monitor that you can choose from the list of other profiles in the Display Preferences pane. You can see the differences between the profile you just created and a stock one included with your Mac (such as Color LCD) by clicking the two different profiles and noting how your screen renders colors. The differences can be quite remarkable.

Calibrating on Windows

Stock monitor profiles are also available on Windows PCs. In Vista, right-click on your desktop and choose Personalize from the contextual menu, and then choose Display Settings. Click the Advanced Settings button, click the Color Management tab, and then click the Color Management button; you'll see the monitor profiles available for your computer.

Even though Windows doesn't have a built-in calibrator, you can use third-party software to help you create a profile. For example, the Adobe Gamma application that comes with Photoshop is a useful tool for checking the accuracy of your monitor.

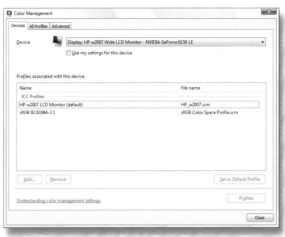

Monitor profiles in Windows.

If you use Windows XP, you can learn more about Adobe Gamma by visiting Adobe Tech Note #321608 (*http://kb.adobe.com*). If you use Vista, you can try Adobe Gamma, but you'll need to fiddle around a little. See the Weblog post on All Things Adobe (*http://allthingsadobe.libsyn.com/index.php?post_id=230489*) for more information.

Calibrating in General

In the end, if you want to get serious about this stage of the color management process, you'll need to invest in a colorimeter. My advice is that you find or create the best profile possible for your computer monitor and follow my other steps for accurate printing. If the results work for you, you're done. If you want to continue to fine-tune the process, investing in a colorimeter is a good first step. I also recommend that you recalibrate about four times a year or before very important printing sessions.

One final note about this endeavor. Your environment does influence your perception of what you're seeing on the screen. Ideally, you'll want neutral-colored walls in the area where you work. Bright orange paint, for example, might say something about your flamboyant personality, but it will also skew your perception of the image on the monitor. It's better to stick with white surfaces if possible.

Lighting comes into play as well. Be wary of strong artificial lights, such as fluo-rescents, that can taint your view of the colors on the screen. Once you've set up your work area and you've calibrated your monitor, you're ready to think about the device you're going to use to actually make the print.

Dedicated Photo Printers

Dedicated photo printers for home and studio work can produce gallery-quality archive prints on a variety of surfaces. Devices such at the Epson R2880 (*www. epson.com*) and the HP 9180B (*www.hp.com*) accept paper up to 13 x 19 inches, letting you create everything from snapshots to fine art.

I mention these two printers as good examples because they're designed to make photographs that are vibrant and that will last. You could use a standard color office printer, but it may not come with photographer-friendly software, such as color profiles for your paper, and the permanence of the prints isn't guaranteed.

Regardless of the particular printer you have, people have a perception about the voodoo that's involved with getting decent enlargements. But thanks to im-proved software and an abundance of paper profiles, today there's a lot more science to printing than there is black magic. Of course, this is true only if you know the steps to follow. With a little organization, you'll soon be churning out beautiful large-format images that will retain their integrity for decades if you store or display them properly.

The Epson R2880 photo printer

Ten Steps to Making a Beautiful Print

Some of the steps I list in this section will feel familiar to you, but I'll also talk about a new concept or two that I haven't discussed before, including ICC pro-files. I'll get to those in a minute. First, here's my basic overview for creating beau-tiful prints at home.

1. Capture the best images possible with your camera.

2. Calibrate your computer monitor to these standards: Target Gamma = 2.2, White Point = 6500. (See "Calibrating Your Monitor" earlier in this chapter.)

3. Upload your images from your camera and select your favorites using the Bridge workflow I cover in Chapters 2 and 3. Fine-tune those candidates using Adobe Camera Raw as I discuss in Chapter 4.

4. Power up your printer and load the paper you want to use. While you're get-ting your feet wet with this process, I recommend that you use paper your printer manufacturer supplies because you probably have an ICC profile for that paper already loaded on your computer; more on this later.

5. Open the image in Photoshop. Go to the Page Set Up dialog box (File→Page Set Up) and make sure your printer is selected in the "Format for" pop-up menu. Also choose the paper size and the orientation. Leave scale at 100 per-cent. Click OK.

6. Now you're ready to print. Open the Print dialog box (File→Print). Here's where you're going to take the voodoo out of printing. First, make sure the correct printer is displayed at the top of the dialog box. If not, change it. The number "1" should be displayed in the Copies field. Also double-check the paper orientation.

7. You're going to choose a few more bits of information, including the following (you can adjust to taste later):

 Position Center Image is the common choice for position, but you won't have to do anything here because of the option you're about to select in the Scaled Print Size area.

 Scaled Print Size Turn on the Scale to Fit Media checkbox and make sure the print resolution is 150 ppi or more. If your print resolution is less than 150 ppi, your image isn't big enough for a photorealistic print. You'll have to either reduce your paper size or find a bigger image. I recommend a resolution of at least 240 ppi.

Bounding Box You should not turn on this option unless you want a dark line to print along the perimeter of the image.

Color Management This option should appear at the top of the second column. If it isn't displayed, choose it from the pop-up menu. Click the Document radio button, and the color profile you established earlier in your workflow will display. A safe bet for printing is Adobe RGB 1998 because it's a reasonably large color space.

Color Handling Photoshop Manages Colors is still my favorite Color Handling setting. But I've noticed that printers are doing a better job of color management these days, so you might want to experiment with Printer Manages Colors too. For now, though, let Photoshop do the heavy lifting.

Printer Profile This can be a rather large pop-up menu displaying a variety of color profiles that are loaded on your computer. Look in the list for the printer/paper stock profile you've loaded in your printer. These are actually specific profiles for the various papers (often ICC profiles). They're added to your system when you load the printer software.

This is an important choice because it helps your printer accurately interpret the calibrated information it receives from the computer.

Rendering Intent Set it to "Perceptual"

Black Point Compensation Turn on the box.

8. Click the Print button. Photoshop may present you with a secondary Print dialog box; this scenario varies depending on the type of printer driver you have loaded on your system. If Photoshop does present you with a secondary Print dialog box, everything should pretty much be all set. But it doesn't hurt to nose around a bit. I usually double-check the Paper Type/Quality setting. This listing is usually in a pop-up menu in this secondary dialog box. Once I'm there, I make sure the paper type is the same as what I've loaded onto the paper tray, and that the quality level is set at Best. If those two parameters check out, click Print again and your printer should go to work. Within minutes, you should be holding your first print of the day.

The Print dialog box.

9. Review the first print in the type of lighting in which it will most likely be displayed, such as window light, halogen light, and so on. Does it look good? It should, but if it doesn't and you want to adjust the tone or color, return to step 3. At this point, you should consider making a duplicate of your master image and adding "print" to the filename. This gives you the latitude to play with tone and color for the specific paper you're printing on without tainting the original image.

10. Sharpen the print (this is an optional but sometimes amazingly effective step). Once you've completed your final adjustments and you feel like the picture is ready for prime time, consider sharpening it a little. I recommend that you zoom out to 50 percent to better visualize the resolution of the print that'll emerge from your printer (monitor is 100 ppi and print will be 150 ppi or 240 ppi). Then use Smart Sharpen (Filter→Sharpen→Smart Sharpen). In Smart Sharpen, choose Lens Blur from the Remove pop-up menu, with a low Radius setting (1 or 1.5 pixels) and a higher Amount setting (25 percent or 50 percent). You may have to adjust to taste, but these are good starting points for making prints.

Make your final print. Be sure to leave the print accessible after printing so that you can enjoy it and learn more about your image as you view it over time.

Very few things are more satisfying than having a tangible print of your image.

A Word About Printer Profiles

The most notable new concept in this workflow is the Printer Profile selection. Often, these are ICC profiles (International Color Consortium). These bundles of information help your printer match the data from your computer to the inks and paper you're going to use. Most photo printers load a set of these profiles onto your computer when you install the driver. I recommend that you start with the paper available from your printer manufacturer because those will be the profiles initially available to you.

> **TIP:** Shop Smartly for Paper
>
> Some independent paper stocks can be just as good as brand names for con-siderably less money. Red River Paper, for example, offers paper that comes in a variety of surfaces, produces great prints, and is often less expensive than printer manufacturer paper. Plus, you can usually download printer profiles from the company's website (*www.redriverpaper.com*) for your particular photo printer.

Independent paper companies often make profiles available on the Web for their papers too. They match to the most commonly used photo printers. So, if you

want to go that route, look on the website of the company whose paper stock you're interested in, and see whether a profile for your printer is available. The company will also tell you how to load the profile onto your computer.

If you're truly ambitious, you can make your own profiles using systems sold by companies such as X-Rite which specialize in color calibration. To start, however, I recommend that you stick with stock profiles available with your printer software or available online until you feel comfortable with your print setup.

A handful of printer profiles displayed in Photoshop's Print dialog box.

Success! A Beautiful Print

Now, here's the good news. If your computer screen is calibrated and you've set up your printer as I described, you'll get good prints. Keep in mind that the photo you look at on your monitor is backlit, and the image that comes out of the printer is reflective—these are two different types of illumination, so you'll see some differences in brightness. But with a tight workflow and a little practice, you'll soon be making beautiful enlargements.

T I P : Try Turning Down the Brightness for Accuracy

If you have a very bright monitor, you may want to ratchet down to about two-thirds brightness for printing. I use an Apple 23-inch Cinema Display, and I've noticed that my prints match the screen better when I have my monitor set to 70 percent brightness.

Improving Your Photography Through Printing

When you print an image and hang it on a wall, you'll look at it more often than if you had left it buried deep in your computer. And if you look at your best pictures more often, you're going to discover strengths and weaknesses about your craft that you may have missed otherwise.

The combination of ink and paper will reveal details and subtleties that weren't apparent before. You'll probably have more conversations about your work because it's more accessible to visitors as they drop by. Prints provide us with much-needed "quality time" with our pictures. Be selective in what you print. Study your best work. Seek out comments from others.

Printing your work enables you to stand back and analyze it over time, which can help you improve your photography.

Reference Tables for Printing

Here are a couple of handy reference tables to consider when you're thinking about the minimum resolution you'll need for various paper stocks, and the different types of paper surfaces to choose from.

Print size	Standard quality (at 150 ppi)	High quality (at 240 ppi)
4 x 6 inches	600 x 900	960 x 1440
5 x 7 inches	750 x 1125	1200 x 1800
8 x 10 inches; 8 x 12 inches	1200 x 1800	1920 x 2880
11 x 14 inches	1650 x 2475	2640 x 3960
13 x 19 inches	1950 x 2925	3120 x 4680

Resolution settings based on desired print size and quality

Type of photo	Recommended paper surface	Comments
Snapshots of events, vacations, daily life	Glossy	Good all-purpose finish that shows high detail and color saturation.
Portraits	Semi-glossy, luster, or matte	The surface texture of the paper complements the subject matter.
Weddings	Luster or matte	Gives images a professional appearance; surfaces don't show fingerprints as easily.
Landscapes and nature (8 x 12 inches or smaller)	Glossy or semi-glossy	Good color saturation and detail.
Landscapes and nature (11 x 14 inches or larger)	Semi-glossy, luster, or matte	Large prints with glossy surfaces can reflect unwanted light. Textured surfaces often work better.

Recommended paper surfaces

Final Thoughts

A good friend once told me that the best way to tackle a big problem is to break it down into parts. I discovered that's what I needed to do with Photoshop. Because, to be honest, for years it was more than I could comprehend. I decided that I wanted to be better with this application. So I took my friend's advice and broke it down into parts. And it worked. Today, I truly enjoy working with Photoshop CS4.

It's funny, now that I look back on my frustrating days with Photoshop, I realize that I just didn't have a good set of instructions to help me figure out which parts I needed, and those I didn't. I hope I've provided that here, enabling you to build your Photoshop workflow piece by piece. And by doing so, helping you can take your photography to the next level with no end in sight.

About the Photos in this Book

Since this is the "photographer's" companion to Photoshop CS4, I want to provide some photographic information about many of the images you're seeing in the book. One of the important aspects of figuring out your postproduction workflow is knowing how much latitude you have to work with while composing your images in the field.

For example, almost every one of these shots was captured in raw mode. By doing so, I knew there was more image information available to me in post than I was seeing on the camera's LCD screen. The "slot canyon" photo is a good example. On the LCD, the image was flat and didn't have much color vibrancy. But I knew that if I worked carefully in raw while shooting, that I could achieve the look I wanted in post.

Capturing good imagery is as important to me as knowing what to do later on in Photoshop. I hope you find this section helpful.

Cover Images

Opening Ceremonies, Beijing Olympics

I was outside the Bird's Nest during the opening ceremonies at the Beijing Olympics. As I was finishing up some portraits, fireworks suddenly lit up the sky. After I captured the first series with the 50mm lens I had mounted, I changed to the wider Canon 16-35mm f/2.8 L zoom lens (on a Canon 5D.) The fireworks were so bright that the shutter speed was 1/90 with an aperture of f/2.8 at ISO 1600. The shot was cropped to fit on the cover, but here's the uncropped version giving you a wider perspective.

Woman

I created this portrait of an Icelandic woman who was an aspiring model with a 300mm Canon lens mounted on a Canon 5D. The ISO set to 160 with an exposure of 1/250 at f/5.6. There was a pleasant light breeze that afternoon that provided a nice lift for her hair.

Flower

During a visit to Orlando, Florida, I spotted this pink flower. I photographed it with a Canon 70-200mm f/4 zoom lens mounted on a Canon 5D. The ISO was 200 with an exposure of 1/250 at f/4.5. The original composition had the flower hanging down. The designer angled it to the right to enhance the cover design.

Young Woman

I was shooting this outdoor portrait series on assignment and was having fun interacting with the young woman as I clicked away. Since I was using burst mode, I captured a lot of great outtakes in the series. This image represents one of the reasons why I enjoy shooting in continuous drive mode. Canon 5D, 280mm focal length, ISO 400, f/4.5 at 1/250.

Butterfly

One of my favorite parks in the world is Stanley Park in Vancouver, British Columbia, where I photographed this butterfly using a Canon XTi with a Canon 200mm lens set to f/4 at 1/90, ISO 400.

Aquatic Center, Beijing Olympics

Fondly known as the Water Cube, this was a beautiful structure, especially at night. I used a Canon 70-200mm f/4 zoom mounted on a Canon 5D to put this composition together. I was actually a distance away, near the Bird's Nest, to get the right perspective. The ISO was 1600 with an exposure of 1/125 at f/4.

Frontmatter Images

Title Page Opener

I visited this slot canyon during a trip to the Kasha-Katuwe Tent Rocks National Monument outside of Santa Fe New Mexico during a teaching stint at Santa Fe Workshops. I mounted a Canon 5D on a tripod and used the 24-105mm f/4 Canon zoom lens. Because I needed a little extra depth of field, I set the aperture to f/11 in Aperture Priority mode. The ISO rating was 100 (to keep the image noise in check). The resulting shutter speed was half a second. That's why you often need a tripod for these types of shots.

The Table of Contents Opener

During a shoot at the Bank of the West Tennis Classic at Stanford University in Palo Alto, California, I was testing an Olympus E-520 with a beautiful piece of glass: the Olympus 150mm f/2 telephoto. Having such a large aperture allowed me to shoot at high shutter speeds to freeze the action. In this case, the exposure was 1/4000 at f/3.2, ISO 400. I overexposed by two-thirds of a stop to compensate for the white tennis shirt that could fool the camera's light meter.

Chapter Openers

Introduction Chapter Opener

While street shooting in Santa Barbara with my friend Bruce Heavin of lynda.com fame, I spotted this interesting light and shadow interplay on the side of an adobe building. I used a Canon 28-300mm IS lens set to 85mm with +1 exposure compensation (1/250 at f/9.5), ISO 200. Bruce had loaned me the lens for the day. I didn't really want to give it back.

Chapter 1 Opener

As I was wandering around Kennedy Space Center in Florida, I spotted this interesting shot of a rocket engine, or at least the exhaust part of one. I used a Canon XTi with a 17-40mm f/4 zoom lens set to 1/45 at f/4.5, ISO 400. I cropped the version that was used for the chapter opener to add drama. Here's the uncropped version as I shot it.

Chapter 2 Opener

Another fireworks shot during the opening ceremonies at the Beijing Olympics. I actually had the wrong lens mounted when I was caught off-guard by the sudden explosions. I just took the shot anyway, and ended up with an interesting composition that I might not have created otherwise. I had a 50mm f/1.4 Sigma lens on my Canon 5D when the fireworks erupted. The exposure was 1/250 at f/3.5 at ISO 1600.

Chapter 3 Opener

As I mentioned earlier, I fell in love with the Olympus 150mm f/2 lens while capturing the action at the Bank of the West Tennis Classic. When mounted on the Olympus E-520 DSLR, the four-thirds sensor effectively doubles the focal length, so you have a 300mm f/2 lens. How nice is that for action photography? 1/2000 at f/3.4.

Chapter 4 Opener

On a drive up to Ghost Ranch, New Mexico, I spotted these two wooden chairs on a hill in the middle of nowhere. I made a U-turn to go back and photograph them with a Canon 5D with a 24-105mm f/4 lens. The exposure was 1/125 at f/11, ISO 200. I still wonder: Why were those chairs there?

Chapter 5 Opener

During a cruise to Costa Maya, I noticed these colorful ropes on the dock with nice texture to boot. I recorded the image with a Canon Rebel XTi and a 24-85mm lens, 1/60 at f/4, ISO 100. I sometimes use this shot for workshops as an example of getting closer to study detail.

Chapter 6 Opener

We're back in Beijing for this image. I had access to the opening ceremonies staging area as the participants were gathering to enter the stadium. I loved the detail of the drums, and I photographed the hand of one of the drummers as he waited for the show to begin. The light was already low, so I had to shoot at ISO 800 with the Canon 5D and the fast Sigma 50mm f/1.4 lens. The exposure was 1/60 at f/1.8.

Chapter 7 Opener

I had a wedding assignment the day after I returned from Beijing. This shot of one of the bridesmaids had that clean, natural look that I thought would work well for this chapter on retouching techniques. The subject was backlit creating a nice rim light on her hair. I used the Canon 5D at 105mm, existing light only. The exposure was 1/125 at f/4.5, ISO 100. Normally I would use a fill light for this shot, but there wasn't time. I thought I had enough data to work with that I could make the image work with some Photoshop retouching.

Chapter 8 Opener

I went for an evening walk while working at a trade show in Las Vegas. I took my Canon G9 with me in case I spotted something interesting. With a mini-tripod, I mounted the camera on a rail on the street overpass, and made this 1.3 second exposure at f/2.8. I kept the ISO low, at 80, because I didn't want to introduce image noise in the dark areas of the composition.

Opener for This Section

One of the things I liked about my recent visit to New Mexico, was how the thunderstorms would roll in during the afternoon, then move on. I learned how to anticipate the dramatic lighting that would ensue. For this shot, I stopped by the side of the highway and hand-held the Canon 5D with the 24-105mm zoom lens. I underexposed by one stop to keep the dark areas rich and full of texture. The ISO was 160 with an exposure of 1/250 at f/11.

Special Thanks to Those Who Helped Me Make These Images

Apple and Kodak were responsible for my visit to Beijing for the 2008 Summer Olympics, and I'm very grateful for the experience of a lifetime—a particular nod of the cap to the Aperture team, especially Joe Schorr and Martin Gisborne. I owe a big thanks to Adobe and Mikkel Aaland who helped organize and underwrite the first Lightroom Adventure to Iceland. Santa Fe Workshops hired me for a week during the summer of 2008, and that got me to beautiful New Mexico. Olympus sponsored my shooting at Bank of the West Tennis Classic and provided the equipment. O'Reilly Media pays my expense reports for trade shows spanning from Las Vegas to New York City. The good folks at Lynda.com make sure I get a couple Southern California visits in each year. Neil Bauman has sent me all over the world as part of his exciting Geek Cruises. And O'Reilly editor, Colleen Wheeler, helped me separate the wheat from the chaff by evaluating dozens of shots from all of these places. If it weren't for these companies and individuals, we would not have these photographs to work with.

Index

A

Adjustment brush, 78–81, 85
Adjustments panel, 89–90
Adobe Camera Raw (ACR), 47–49
 Basic tab, 55–59
 batch processing, 70–72
 benefits, 50
 black-and-white conversion, 72–73
 Bridge images, 50–53
 cropping, 54–55
 Detail tab, 66–68
 HSL/Grayscale tab, 64–66, 73–75
 localized corrections, 78–81
 spot removal, 75–78
 tonal and color adjustments, 81–85
 Tone Curve tab, 59–64
Adobe Gamma, 159
Adobe RGB color space, 52
Advanced Dialog view, 12
All Subfolders option, 41
Always High Quality option, 34
Amount setting in sharpening, 66–67, 110
Apply Preset option, 71
Applying Metadata section, 20–22

architectural distortion correction, 128–131
Author field, 154
Auto-Align layers option, 150
Auto-Blend in depth of field, 149
Auto-Blend Layers dialog box, 150–151
Auto Mask function, 81
Auto option for Levels adjustment layers, 98
Auto Stack Panorama/HDR option, 145

B

Background Colors option, 101
backups
 Bridge edits, 45
 DNG, 20
 FireWire drives, 18
 importing images, 9–11
Basic tab in ACR, 55
 color adjustments, 58
 fine-tuning in, 59
 tone adjustments, 55–58
batch processing
 ACR, 70–72
 renaming, 15

Birdseye View, 91
bit depth, 51–52
black-and-white conversion, 72–73
Black Point Compensation option, 162
Blacks slider, 56
blemishes, 117
blending modes
 Clone Stamp, 93
 facial features, 118–119
 Levels adjustment layers, 99–100
 nondestructive sharpening, 111
 virtual custom mattes, 144
blown-out skies, 131–133
Blues slider, 65
blur
 nondestructive sharpening, 110
 printing, 163
 skin softening, 120
Bounding Box option, 162
Bridge, 23–24
 ACR for, 50–53
 backups, 45
 keywording, 43–45
 Keywording workspace, 31–32
 Overview workspace, 25–30
 Photo Edit workspace, 30–31
 reviewing shots, 33–34
 sorting and rating pictures, 35–42
 workspace setup, 24–25
Bridge Masters folder, 15, 27
brightening
 eyes, 121
 teeth, 115–116
brightness, monitor, 166
Brightness slider
 desaturation, 74
 Graduated Filter tool, 83
 midtones, 56

Brush tool
 facial features, 119
 teeth brightening, 116

C

calibrating monitors, 156–160
Camera Raw Defaults setting, 61
 camera raw editing. *See*
 Adobe Camera Raw
 (ACR)
Cancel option, 53
canvas for virtual custom mattes, 144
card readers
 benefits, 6
 listing, 13
Center Image option, 161
Check All option, 13
circles under eyes, 123–124
Clarity slider
 Graduated Filter tool, 83
 midtone contrast, 59
clipping
 Exposure slider, 56
 shadow clipping warning indicator,
 57, 64
Clone Stamp tool, 91–94
cloning with Spot Removal brush, 77
collections, 27
 for ratings, 37
 in Review Mode, 40
 Smart Collections, 41–42
color
 ACR adjustments, 58
 black-and-white conversion, 72–73
 changing, 137–141
 color wash, 134–136
 Convert to Grayscale option,
 73–74
 Graduated Filter tool, 81–85
 monitor calibration, 156–160

Color Handling option, 162
Color Management option, 162
Color noise reduction, 68
Color Range option, 139
Color Replacement tool
 color change, 137, 140–141
 color wash, 134–135
color space selection, 52
colorimeters, 157–158
comparing photos, 38–39
compression
 DNG conversions, 18
 dynamic range, 82
 lossy, 49
consistency in organization, 15
Content Filmstrip, 30
Content space, 28
Contrast slider
 Exposure slider, 56
 Graduated Filter tool, 83
contrast with Unsharp Mask, 125
conversion
 black-and-white, 72–73
 grayscale, 66, 73–75
 layers to SmartObjects, 106
 raw files to DNG, 16–18
Convert to DNG option, 18, 20
Convert to Grayscale option, 66,
 73–75
Convert to SmartObject option, 106
Copies setting, 161
Copyright field, 20–21, 153
copyright information
 metadata, 20–21, 153
 saving, 153–154
Copyright Notice field, 154
Create Subfolder option, 13
Creator field, 20–21, 153
cropping in ACR, 54–55

curves, tone, 59–64
Curves control, 56
custom mattes, 144
Custom Name option, 14–15
Custom Settings setting, 61
custom workspaces, 25

D

darkening facial features, 118–119
darkrooms, digital, 2
darks region in ACR, 62
dedicated photo printers, 160
Default Foreground option, 101
Delete Adjustment Layer icon, 97
Delete Original Files option, 18
deleting below-par images, 36
Density slider for Adjustment brush,
 79
depth of field in stacking images,
 149–152
desaturate approach, 74–75
Deselect All option, 45
Detail tab
 noise reduction, 68
 sharpening, 66–67
Develop Settings option, 71–72
diameters
 Adjustment brush, 79
 Clone Stamp tool, 92, 94
 Spot Healing brush, 117
 Spot Removal tool, 77
digital darkroom guidelines, 2
Display Preferences pane, 157–158
DNG files, 16–18
Do not rename files option, 15
Dock for imported images, 9
Done option in ACR, 53
Double-Click Edits Camera Raw
 Settings in Bridge option, 50

drives
 backup, 10
 external FireWire, 18
Drobo product, 11
DVDs for backups, 10

E

Eismann, Katrin, 48, 74, 137
Epson photo printers, 160
Essentials workspace, 26
EXIF data, 34
Exposure slider
 desaturation, 74
 Graduated Filter tool, 83–84
 tone adjustments, 55–58
external FireWire drives, 18
Eye-One Display LI calibrator, 156
eyedroppers
 color change, 137–138
 color wash, 134
 Levels adjustment layers, 98–99
 Targeted Adjustment icon, 115
 White Balance, 54, 58
eyes
 brightening, 121
 circles under, 123–124
 sharpening, 122

F

facial features, darkening and
 lightening, 118–119
Favorites tab, 26
feathering
 Adjustment brush, 78–79
 Spot Removal brush, 77
fields, metadata, 28–29
files
 renaming, 15–16
 saving, 94–96

Fill Light slider, 56
Filmstrip option, 30
filters
 Lens Correction, 129
 noise, 68
 nondestructive sharpening, 110
 ratings, 37
 RAW+JPEG images, 42
 tonal and color adjustments,
 81–85
Find dialog box, 44
Find Edges option, 135
FireWire drives, 18
flat images, 88, 90
folders
 Photo Downloader, 13–15, 19
 size, 27
foreground colors, 101–103
Free Transform tool, 147
Free Transformation option, 130

G

Gaussian Blur
 nondestructive sharpening, 110
 skin softening, 120
Get Photos from Camera option, 9,
 153–154
Graduated Filter tool, 81–85
Grayscale Mix tab, 73
Group as Stack option, 72

H

Hand tool, 76
hard drives
 backup, 10
 external FireWire, 18
Heal mode for Spot Removal tool, 78
Healing brush, 117
Hide Empty Fields option, 28
High Quality on Demand option, 34

highlights region in ACR, 62
histograms
 clipping, 57, 64
 Levels adjustment layers, 100
 tone curves, 60, 62–63
Horizontal Perspective slider, 129
HP photo printers, 160
HSL/Grayscale tab, 64–66, 73–75
hue
 changing, 138, 140, 142–143
 settings, 64–65
Hue/Saturation settings
 color change, 139–142
 Levels adjustment layers, 101
 teeth brightening, 115–116
huey calibrator, 156

I

image editing vs. photo editing, 31
Image Settings
 ACR, 61
 spot removal, 76
importing images, 5–6
 metadata templates for, 6–8
 Photo Downloader. *See* Photo
 Downloader
 preparation, 6
input sharpening, 66–67
IPTC Core, 7
ISO setting, 33–34

J

JPEG files
 ACR support, 49
 backup drives for, 10
 bit depth, 52
 black-and-white conversion, 72
 RAW+JPEG, 18, 42
 saving, 53
 XMP metadata, 16

K

Keep in Dock option, 9
Keywording workspace, 31–32
keywords, 43
 adding, 44–45
 setting, 28
 tools, 43–44

L

labels, 15
layer masks
 Levels adjustment layers, 101–105
 nondestructive sharpening, 110
 skin softening, 120
layers
 requirements, 90
 stamping, 126–127
Lens Blur
 nondestructive sharpening, 110
 printing, 163
Lens Correction filter, 129
Levels adjustment layers, 89, 96
 creating, 96–101
 guidelines, 106
 masks, 101–105
lightening facial features, 118–119
Lightness slider, 138, 140
lights region in ACR, 62
List view, 33
Local Adjustments option, 85
localized corrections, 78–81
lossy compression, 49
loupe, 38–39
Luminance noise reduction, 68
Luminance settings, 64–65
Luminosity blending mode
 nondestructive sharpening, 111
 tone adjustments, 99–100

M

Mac OS X monitor calibration, 157–158
magnifying glass, 38–39
marching ants, 124
masks
 Adjustment brush, 79–80
 Levels adjustment layers, 101–105
 sharpening, 67, 110
 skin softening, 120
McClelland, Deke, 90
memory card readers
 benefits, 6
 listing, 13
memory cards for backups, 10
merging, panorama, 145–148
metadata
 applying during downloads, 20–22
 Overview workspace, 28
 sidecar files, 22
 suggested fields, 28–29
 templates, 6–8
 web images, 153–154
 XMP, 16–17, 46
midtones, 48, 56
monitor calibration, 156–160
multiple images as tabs, 152

N

names
 files, 15–16
 folders, 14–15
 in published images, 153
 SmartObjects, 107
 templates, 7
 workspaces, 30
New Collection icon, 37
New Smart Collection icon, 41
New Workspace option, 30

noise reduction, 68
nondestructive environment
 ACR as, 50
 Smart Objects sharpening, 106–112
Normal blending mode
 Clone Stamp, 93
 Levels adjustment layers, 100
 virtual custom mattes, 144

O

Opacity settings
 eyes brightening, 121
 facial features, 118
 Levels adjustment layers, 100, 104
 sharpening, 122
 skin softening, 120
 spot removal, 76–77
 teeth brightening, 116
Open Image option, 53
Open Image from ACR option, 153
Open in Camera Raw option, 50
opening SmartObjects, 108
optimizing images and copyright information, 153–154
Oranges slider, 65
overlay feature
 Clone Stamp, 93
 spot removal, 77
Overview workspace, 25
 creating, 26–30
 reviewing shots in, 33–34

P

Page Set Up dialog box, 161
panorama merging, 145–148
paper
 recommendations, 167
 size, 161
 sources, 164

Paper Type/Quality setting, 162
Patch tool, 123
Path Bar, 27
performance
 quality levels, 34
 zooming, 119
Photo Downloader, 5–6
 advanced options, 16–19
 backups, 9–11
 basic options, 12–16
 launching, 8–9
 metadata during downloads, 20–22
 metadata templates, 6–8
Photo Edit workspace, 30–31
photo editing
 vs. image editing, 31
 sorting and rating pictures, 35–42
photo management. See Bridge
photo printers, 160
Photoshop
 recipes, 113–114
 architectural distortion correction, 128–131
 color change, 137–141
 color wash, 134–136
 copyright information, 153–154
 depth of field, 149–152
 hue and saturation, 142–143
 panorama merging, 145–148
 portrait retouching. See portrait retouching techniques
 sky correction, 131–133
 virtual custom mattes, 144
 tools, 87–91
 Clone Stamp, 91–94
 Levels adjustment layers, 96–106
 saving files, 94–96
 Smart Objects, 106–112
Point tab, 62, 64

portrait retouching techniques, 114
 blemishes, 117
 circles under eyes, 123–124
 contrast enhancement, 125
 eyes and eyebrows sharpening, 122
 eyes brightening, 121
 facial features darkening and lightening, 118–119
 skin softening, 120
 stamping, 126–127
 teeth brightening, 115–116
Position option in printing, 161
Preserve Current File Name in XMP option, 16
Preserve Raw Image option, 18
presets in batch processing, 71
previews
 DNG conversions, 18
 Exposure slider, 58
 Overview workspace, 28
 Photo Edit workspace, 30–31
 sharpening, 67
 spot removal, 77
Previous State icon, 97
printing, 155–156
 brightness in, 166
 learning from, 166
 monitor calibration, 156–160
 photo printers, 160
 profiles, 162, 164–165
 reference tables, 167
 steps, 161–164
Process Collections in Photoshop option, 146
profiles
 color, 158–159
 printing, 162, 164–165
Promote to Top of Stack option, 73, 95
ProPhoto RGB color space, 52

Q

quality
 performance effect, 34
 printing, 167
Quick Selection tool, 134

R

Radius slider
 sharpening, 66–67, 110, 122, 163
 spot removal, 76–77
ratings, 35–38
 comparing photos, 38–39
 RAW+JPEG images, 42
 Smart Collections, 41–42
raw files
 backup drives for, 10
 converting to DNG, 16–18
 editing. *See* Adobe Camera Raw
 (ACR)
 sidecar files, 22
RAW+JPEG images, 18, 42
Recovery slider, 56
Rectangular Marquee tool, 137
Reds slider, 65
reducing noise, 68
reference tables for printing, 167
region markers, 62
renaming files, 15–16
Rendering Intent option, 162
Replace Color option, 137
Reset option
 ACR, 53
 Levels adjustment layers, 97
resolution settings
 ACR, 52
 printing, 161, 163, 167
Review Mode, 40
RGB color space, 52
Rights Usage field, 7

rotating images, 141
Rowell, Galen, 83

S

Saturation settings, 142–143
 Adjustment brush, 79
 color, 59, 64–65, 138, 140
 desaturate approach, 74
 Levels adjustment layers, 101
Save Copies to option, 18–20
Save for Web option, 153
Save for Web & Devices option, 153
Save Image option, 53
Save Settings option, 71
Save Sort Order as Part of Workspace
 option, 30
Save Window Location as Part of
 Workspace option, 30
saving
 copyright information, 153–154
 Photoshop files, 94–96
 workspaces, 30
Scale to Fit Media option, 161
Scaled Print Size option, 161
Screen mode for eyes brightening, 121
Seamless Tones and Collectors option,
 150
Search window, 43–44
Select All option, 70
shadow and highlight clipping
 warnings, 57, 64
shadows region in ACR, 62
sharpening
 eyes and eyebrows, 122
 Graduated Filter tool, 83, 85
 input, 66–67
 nondestructive, 106–112
 printing, 163
Show Mask option, 79–80
Show Metadata Placard option, 28

Show Overlay option, 77
sidecar files, 16–17, 22
size
 ACR setting, 52
 Adjustment brush, 79
 Clone Stamp tool, 92–93
 folders, 27
 paper, 161
 printing, 167
 region markers, 62
 thumbnails, 28
skies, 131–133
skin
 skin tones, 65
 softening, 120
Smart Collections, 27
 creating, 41–42
 in keywording, 44
Smart Objects, 90–91
 in ACR, 52
 nondestructive sharpening,
 106–112
 opening, 108
Smart Sharpen tool, 90
 eyes and eyebrows, 122
 nondestructive sharpening,
 109–112
 printing, 163
Soft Light blending mode, 118–119
softening, skin, 120
sorting, 35–38
 comparing photos, 38–39
 RAW+JPEG images, 42
 Review Mode, 40
 Smart Collections, 41–42
sources
 Clone Stamp, 93
 Photo Downloader, 12–13
Spot Healing brush, 117
spot removal, 75–78

sRGB color space, 52
stacks
 black-and-white conversion, 72
 depth of field, 149–152
 working with, 95–96
stamping layers, 126–127
Straighten tool, 129
subkeywords, 45
Synchronize settings
 batch processing, 70–71
 Graduated Filter tool, 85
 spot removal, 77

T

tabs, multiple images as, 152
Targeted Adjustment tool
 hue and saturation, 142
 teeth brightening, 115
teeth brightening, 115–116
Temperature slider
 color, 58
 desaturate approach, 74
templates, metadata, 6–8
thumbnails
 ACR, 50
 batch processing, 70
 for keywording, 32
 Levels adjustment layers, 103–105
 panoramas, 147
 Photo Downloader, 12–13
 rating, 36–37
 reviewing, 33–34
 size, 28
 spot removal, 76
TIFF files
 ACR support, 49
 black-and-white conversion, 72
Tint slider
 color, 58
 desaturate approach, 74

Tolerance setting, 135
tonal adjustments
 Exposure slider, 55–58
 Graduated Filter tool, 81–85
 Levels adjustment layers, 96–101
 Tone Curve tab, 59–64
Tone Curve tab, 59–64
top-level keywords, 45
Transparency setting, 129

U

UnCheck All option, 13
Unsharp Mask, 125

V

versioning control, 61
Vertical Perspective slider, 129
Vibrance slider
 desaturate approach, 74
 description, 59
virtual custom mattes, 144

W

web, saving copyright information on,
 153–154
When a Camera is Connected, Launch
 Adobe Photo Downloader
 option, 8–9

White Balance tool, 58
Windows monitor calibration,
 158–159
Workflow Options dialog box, 51–52
workflow overview, 1–2
 basic steps, 3
 digital darkroom, 2
workspaces
 Keywording, 31–32
 Overview, 25–30
 Photo Edit, 30–31
 setting up, 24–25

X

XMP metadata, 16–17, 46

Y

Yellows slider, 65

Z

zooming
 Birdseye view, 91
 Clone Stamp tool, 93–94
 performance, 119
 printing, 163
 sharpening, 67
 teeth brightening, 115

Learn from a Master

Boundless enthusiasm and in-depth knowledge...

That's what Deke McClelland brings to Photoshop CS4. Applying the hugely popular full-color, One-on-One teaching methodology, Deke guides you through learning everything you'll need to not only get up and running, but to achieve true mastery.

- **12 self-paced tutorials** let you learn at your own speed
- **Engaging real-world projects** help you try out techniques
- **More than five hours of video instruction** shows you how to do the work in real time
- **850 full-color photos, diagrams, and screen shots** illustrate every key step
- **Multiple-choice quizzes in each chapter** test your knowledge

Adobe **Photoshop CS4** one-on-one.

DVD-ROM features over 3 hours of lynda.com video hosted by Deke McClelland

deke PRESS O'REILLY

DEKE McCLELLAND

deke PRESS O'REILLY®

digitalmedia.oreilly.com

Join the conversation.
digitalmedia.oreilly.com

comprehensive tutorials informative podcasts technical articles
shortcuts recipes forums

O'REILLY®